CROW'S SHADOW INSTITUTE OF THE ARTS AT 25

CROW'S SHADOW INSTITUTE OF THE ARTS AT 25

heather ahtone, Rebecca J. Dobkins, Prudence F. Roberts

Hallie Ford Museum of Art
Willamette University
Salem, Oregon

Distributed by
University of Washington Press
Seattle and London

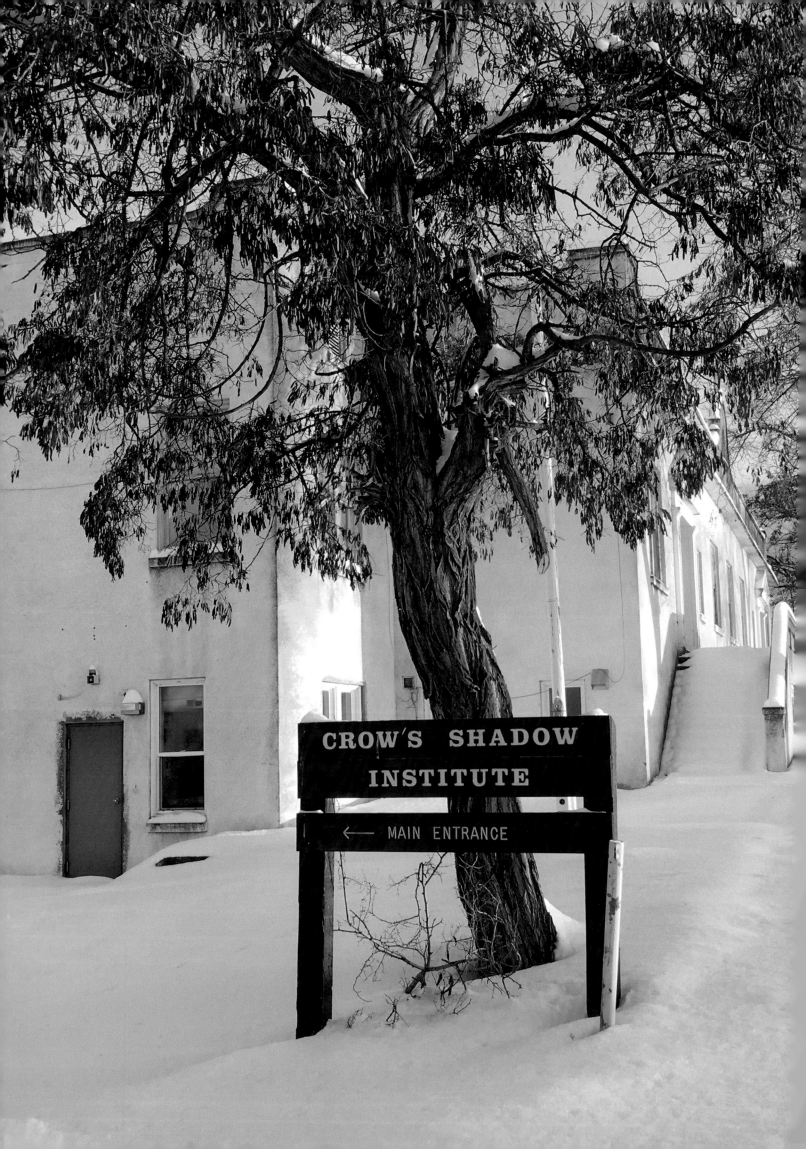

CONTENTS

PREFACE
John Olbrantz, Karl Davis
7

CROW'S SHADOW INSTITUTE OF THE ARTS AT 25:
A HISTORY
Prudence F. Roberts
10

THE EMERGENCE OF INDIGENOUS PRINTMAKING
IN NORTH AMERICA
heather ahtone, Rebecca J. Dobkins
30

PLATES
61

NEZ PERCE ARTIST RESIDENCY, CSIA, 2007
140

Glossary of Printmaking Terms
147

CSIA Artists in Residence and Year(s) in Residency
149

CSIA Exhibition History
155

CSIA Board of Directors
157

Hallie Ford Museum of Art and CSIA Staff
158

About the Authors
159

The Crow's Shadow Institute of the Arts in Pendleton, Oregon, was founded by Oregon painter and printmaker James Lavadour (Walla Walla), who envisioned a Native printmaking atelier on the Umatilla Reservation near Pendleton that would provide a creative conduit for educational, social, and economic opportunities for Native Americans through artistic development. From its modest beginnings in 1992, it has emerged as one of the most important printmaking ateliers in the country, bringing Native and non-Native artists from around the world to make prints under the guidance and direction of master printer Frank Janzen. Prints produced at Crow's Shadow can be found in some of the foremost public and private collections in the United States, and exhibitions drawn from the Crow's Shadow Print Archive have been shown at the Pataka Museum of Arts and Culture in Porirua City, New Zealand (under the leadership of Darcy Nicholas and in collaboration with Toi Māori) and the National Museum of the American Indian in Washington, DC, among many others. During the past twenty-five years, Crow's Shadow has become one of Oregon's artistic treasures.

It is fitting and appropriate that the Hallie Ford Museum of Art should partner with the Crow's Shadow Institute of the Arts to celebrate Crow's Shadow's twenty-fifth anniversary in 2017 with a major exhibition and book. From its inception in 1998, the Hallie Ford Museum of Art has been dedicated to the collection, preservation, exhibition, and interpretation of historic and contemporary Native American art, with an emphasis on the art of the region. Moreover, from 2006 to 2014, the Hallie Ford Museum of Art organized biennial exhibitions of prints produced at Crow's Shadow during the previous two years, and since 2012 has been the official repository for the Crow's Shadow Print Archive, which includes one example of each print produced at Crow's Shadow since 2001. The ties and ongoing relationship between the two organizations remain deep, committed, and strong.

On behalf of the Hallie Ford Museum of Art, Willamette University, and the Crow's Shadow Institute of the Arts, we wish to express our thanks and appreciation to a number of individuals and organizations whose help, commitment, and support brought this project to fruition. We would like to thank Prudence F. Roberts, an art historian who teaches at Portland Community College and serves on the Board of Directors at Crow's Shadow, for her informative essay on the history of Crow's Shadow

over the past twenty-five years. We are further indebted to heather ahtone (Choctaw/Chickasaw), the James T. Bialac Associate Curator of Native American and Non-Western Art at the Fred Jones Jr. Museum of Art at the University of Oklahoma in Norman, and Rebecca J. Dobkins, Professor of Anthropology at Willamette University and Curator of Native American Art at the Hallie Ford Museum of Art, for their excellent essay on the history of Indigenous printmaking in North America.

A project of this complexity involves many people. As always, we would like to thank graphic designer Phil Kovacevich for his masterful design of the Crow's Shadow book; editor Sigrid Asmus for her skillful proof-editing of the entire manuscript, including both the essays and all the other text materials; and photographer Dale Peterson for his beautiful photography of the Crow's Shadow prints. We are further indebted to the University of Washington Press, Seattle and London, for its willingness to distribute the book, assuring worldwide distribution and readership. We wish to thank the Whatcom Museum in Bellingham, Washington, and the Jordan Schnitzer Museum of Art, at Washington State University in Pullman, for agreeing to present the exhibition in 2018.

At the Hallie Ford Museum of Art, we would like to thank its dedicated, talented, and hard-working staff for their help with various aspects of the project: collection curator Jonathan Bucci; education curator Elizabeth Garrison; contract preparator Silas Cook; membership/public relations manager Andrea Foust; administrative assistant Carolyn Harcourt; collection assistant Melanie Weston; front desk receptionists Emily Simons and Leslie Whitaker; safety officer Frank Simons; and custodian Cruz Diaz de Estrada. At the Crow's Shadow Institute of the Arts, we wish to thank master printer Frank Janzen, press assistant and volunteer extraordinaire Marie Janzen, and marketing director Nika Blasser. In addition, we would like to express our thanks and appreciation to Father Michael

Fitzpatrick and the St. Andrew's Mission for housing Crow's Shadow for the past twenty-five years, as well as to Chairman Gary Burke and the Board of Trustees of the Confederated Tribes of the Umatilla Indian Reservation for continuing to support Crow's Shadow's mission and programming.

Financial support for the exhibition and book was provided by a number of different sponsors. First and foremost, we wish to thank the Ford Family Foundation in Roseburg, Oregon, for providing a major grant to support the exhibition and book. Additional financial support was provided by a grant from the James F. and Marion L. Miller Foundation; by an endowment gift from the Confederated Tribes of Grand Ronde, through their Spirit Mountain Community Fund; and by general operating support grants from the City of Salem's Transient Occupancy Tax funds and the Oregon Arts Commission.

Finally, and by no means least, we would like to express our thanks and appreciation to painter and printmaker James Lavadour for having the vision and drive to create the Crow's Shadow Institute of the Arts twenty-five years ago, and to master printer Frank Janzen for helping to guide Crow's Shadow over the past sixteen years and for introducing dozens and dozens of Native and non-Native artists from around the world to the beauty, complexity, and timelessness of the printmaking medium.

JOHN OLBRANTZ
The Maribeth Collins Director
Hallie Ford Museum of Art, Willamette University

KARL DAVIS
Executive Director
Crow's Shadow Institute of the Arts

FRANK JANZEN (Canadian, b. 1943), Untitled, 2008, monoprint,
15¼ x 22¼ in., Hallie Ford Museum of Art, Willamette University,
purchased with endowment funds from the Confederated Tribes of the
Grand Ronde, through their Spirit Mountain Community Fund.
Photo: Frank Miller.

Figure 1. JAMES LAVADOUR (Walla Walla, b. 1951), *Crow's Shadow*,
1987, oil on canvas, 48 x 34 in., private collection.
Photo: Walters Photographers.

CROW'S SHADOW INSTITUTE OF THE ARTS AT 25: A HISTORY

Prudence F. Roberts

Crow's Shadow Institute of the Arts provides a creative conduit for educational, social, and economic opportunities for Native Americans through artistic development.
—Mission Statement

INTRODUCTION

Crow's Shadow Institute of the Arts (CSIA) was born from the dreams of an artist a quarter century ago. It remains as unique today—and as grounded in community—as when James Lavadour (Walla Walla, b. 1951), one of Oregon's most prominent painters, conceived of starting an art institute and named it after one of the first paintings he sold as an emerging artist (fig. 1). And, while its path has been circuitous at times, Crow's Shadow has always been true to its roots: it is a place that celebrates innovation, collaboration, and creativity. Through the dedication and vision of Lavadour and a handful of early supporters, its first home—a studio with a leaking roof—has grown into a state-of-the-art printmaking facility staffed by a master printer. It is housed in the former St. Andrew's School, part of a Catholic mission originally founded in 1847 and located on the Confederated Tribes of the Umatilla Indian Reservation (CTUIR) outside Pendleton, Oregon. It is perhaps the only professional printmaking studio on a Native American reservation in the United States. To get there, you turn off Emigrant Road and drive a short distance through wheat fields to reach a Spanish-

style building adjacent to a modern Catholic Church and meeting hall. Cottonwoods line the creek in back and the foothills of the Blue Mountains rise up around you. It is surprising and a bit incongruous to walk from the somewhat dilapidated parking lot into a beautiful gallery that adjoins a state-of-the-art printmaking studio (fig. 2).

The list of visitors who have made the trip out to Crow's Shadow includes not only luminaries of contemporary Native American art but also tribal youth, aboriginal printmakers from around the globe, and artists skilled in techniques like weaving, beading, and papermaking, as well as a growing number of prominent regional artists. Works printed at Crow's Shadow Press have been sold at prestigious, by-invitation art fairs, have traveled to exhibitions worldwide, and can be found in the collections of the Library of Congress, the Whitney Museum of American Art, the Portland Art Museum, the Eiteljorg Museum of American Indians and Western Art, and the collection of the Portland, Oregon, based print collector Jordan D. Schnitzer. This movement of art radiating from the relatively isolated Umatilla reservation has brought vital recognition to artists and to the organization itself.

Figure 2. Crow's Shadow Gallery, 2016. Photo: Walters Photographers.

THE EARLY YEARS: 1992–2000

The idea of bringing art in some form to the reservation had been a dream of Lavadour's for many years. He has spent most of his life on the reservation, and art, in one form or another, has always been a part of his experience. Although he was surrounded by artists, few of them were able to call art their profession, and nearly all had to leave the reservation for training or education. For most tribal members, traveling and leaving jobs and family for access to art instruction was a hardship. So Lavadour's goal was to bring materials, equipment, and training to tribal members where they lived. He had lacked such resources himself. As a young painter, he had struggled to find his way into a mainstream art world and to learn how to navigate the complexities of galleries, collectors, and museums. "As I began exhibiting and understanding the way the art world works." he recalls, "I realized that all of those things that make up a vibrant artistic community were missing here."[1]

Lavadour wanted to change that and saw the potential of the St. Andrew's building as a staging ground. Back in the 1970s and early 1980s, the CTUIR had used part of the schoolhouse for its education offices, and Lavadour was familiar with the building. When it became vacant, in the late 1980s, he approached the parish priest—then Father James P. Hurley—about renting one of the classrooms as a studio. Another artist, Philip Cash Cash (Cayuse/Nez Perce), eventually rented the room next door. The two were among the original founders of Crow's Shadow, along with Lavadour's wife at the time, JoAnn, who suggested the name Crow's Shadow.[2]

Both Lavadour and Cash Cash had recently discovered printmaking. In 1991, Cash Cash had completed an artist's residency at Tamarind Institute at the University of New Mexico in Albuquerque, considered the preeminent lithography studio in the United States. The year before, 1990, Lavadour was one of six Native American artists to receive a fellowship from the Rutgers Center for Innovative Print and Paper at Rutgers University, New Brunswick, New Jersey. There, he worked with the artist and Tamarind-trained master printer Eileen Foti, then master printer in residence. She and Lavadour developed an instant rapport, and her continuing counsel and support have been integral

to Crow's Shadow over the years. As Foti recalls, Lavadour, who had worked only in paint, "immediately fell in love with the idea of printmaking and collaboration."[3]

Lavadour saw printmaking, with its roots in community and its relative accessibility, as a viable way for CTUIR artists to enter a broader, mainstream art world, and to gain a potential source of income. By 1992, Lavadour was receiving critical acclaim and awards for his work. He was represented by a blue chip Portland art dealer (Elizabeth Leach Gallery), and had shown in Seattle and elsewhere. Important collectors and museums had started to buy his paintings. He was able to support himself and his family through art sales and commissions. So he had a foot in the art world but he was also a tribal member—someone whose life was utterly linked to the land where he and his family had lived for generations. He was invested in the success of the reservation and its people. Lavadour had held an assortment of jobs with CTUIR over the years— from education to counseling to land use planning. He wanted to contribute to the Tribes' new sense of direction and self-sufficiency, and also to give emerging artists opportunities and a sense of community that had eluded

him as he taught himself his craft. His experience helped him understand how an art-making enterprise might fit into the fabric of tribal economic and social development that was being designed in the 1980s and 1990s. Those were the years when the CTUIR began to see themselves as employers and builders, and took their destiny into their own hands—bringing salmon back to the Umatilla River, and writing an economic development plan with concerns for the land and the environment as core values. Beginning with its constitution in 1949, CTUIR had sought self-governance and self-sufficiency in the modern era. The 1980s and 1990s were a time of growth, both in terms of infrastructure and investment. The passage of the federal Indian Gaming Regulatory Act in 1988, which established the terms for Indian gaming enterprises across the U.S., was a green light for further development: a casino, hotel, golf course, and museum and interpretive center were all in the final planning stages when Crow's Shadow came into being. While not directly affiliated with these developments, CSIA was seen by the tribal government as complementary to its efforts and thus the Tribes offered both philosophical and financial support to the endeavor.

Until he resigned the board presidency in 2000 (he is currently a board member), Lavadour divided his time and resources between his own artmaking and his work on behalf of Crow's Shadow—no small sacrifice for an artist at the height of his career. As Foti has noted,[4] Lavadour's high profile and impeccable reputation helped to open many doors and won over supporters in the art world. She marveled at how easily Crow's Shadow initially received grants and publicity: funds quickly came in from numerous sources, including the Northwest Area Foundation and the Flintridge Foundation.

From the time of its inception in 1992, CSIA also received tribal support. In its first year, the CTUIR voted to include CSIA in a five-year grant from the Bureau of Indian Affairs' Community and Economic Development Grant program in the amount of $15,000. The monies were used to begin operations and to plan for a renovation of the lower floor of St. Andrew's Mission School, which was then and is still owned by the Catholic Church (diocese of Baker). Lavadour worked with an attorney to craft an agreement whereby he and CSIA have a rent-free lease in exchange for maintenance and repairs.[5] The rooms on the ground level had

been out of use for several years and were pretty much a mess—unheated and dirty. But, by the summer of 1993, a press was installed in an unheated 400-square-foot space on the second floor (Lavadour himself supplied the heating system), and the first prints were being pulled by Lavadour and, occasionally, by visiting artists, including Treanha Hamm, an Aboriginal printmaker from Australia, and master printer Tadashi Toda from Kyoto, Japan.

The press itself signaled Lavadour's attention to detail and his desire for professionalism. With the proceeds from a sale of his monoprints, Lavadour was able to acquire a press made by the legendary Ray Trayle (1920–2012) of Portland. Trayle's presses (there are sixty-three in existence) are coveted by Northwest printmakers for their elegant design as well as their durability and ease of use. No two are alike: Trayle, a retired machinist, made each according to the specifications of his clients, and charged only for materials and labor.

Among the many individuals who stepped forward to help with supplies, advice, and hands-on expertise were artist and collector Gordon Gilkey (1912–2000), who headed

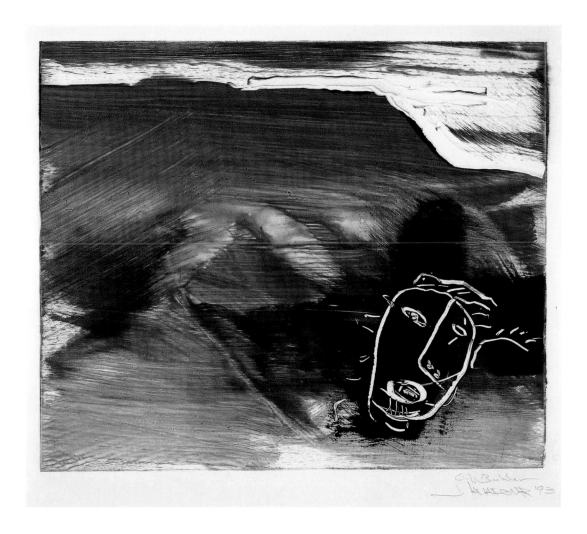

the printmaking department at Pacific Northwest College of Art (PNCA) in Portland and was Curator of Prints and Drawings at the Portland Art Museum; Christy Wyckoff and Tom Prochaska, both printmakers and instructors at PNCA; and artist and professor of art Keiko Hara from Whitman College, Walla Walla, Washington (fig. 3). A 1994 article in the newsletter of the Eastern Oregonian Arts Council notes:

> The centerpiece of Crow's Shadow is a large print-making press constructed by Ray Trayle, a retired Portland machinist, and assembled at Crow's Shadow in August of 1993. Artist printmakers who have worked with the press in recent months include Keiko Hara and Kim Abraham of Whitman College, Philip Minthorn [now Cash Cash], and Clifford Buehler. Tom Prochaska from the PNCA will lead printmaking sessions later this winter.[6]

In forming the first board, Lavadour chose members who would represent both tribal and outside interests. As of 1993, there were five tribal members: Lavadour; Raphael Hoffman (Nez Perce), a local businesswoman; Jo Motanic

Lewis (Umatilla), artist; Antone Minthorn (Cayuse), a visionary political leader; and Patrice Hall Walters (Umatilla), photographer. The remaining seven members, drawn from Seattle and Portland, were involved in fundraising, museum work, and the commercial art world.

Crow's Shadow's first executive director, Marie Hall, began work in November 1993. Hall, a longtime Pendleton resident, brought her knowledge of the community and her background in education and economic development to the position. She saw Crow's Shadow through the first four years, serving in multiple roles when staffing was minimal. She spent much of her time working on grants and fundraising: the organization's first order of business was to raise $150,000. Lavadour hired Tom Hampson, who had worked for CTUIR for many years, as a consultant, tapping into his expertise in governance and his liaisons with both the tribal community and funding sources. Hampson's experience had been instrumental in helping tribal leaders with economic development plans that prioritized natural resources, land use, and education. Hampson and Lavadour had a longstanding relationship; Hampson understood the central role art plays in tribal

Figure 4. James Lavadour and USDA representative Scott Duff, whose Rural Business Enterprise program helped fund CSIA's renovation, 1996. Photo: Marie Hall.

Figure 5. Eileen Foti at Crow's Shadow, ca. 1997. Photo: Roberta Lavadour.

culture (fig. 4). Lavadour had also worked with Hampson's wife, Woesha, the original director of tribal education, in developing curriculum.

In those early years, as it sought to raise money and gain recognition, CSIA was still formulating its structure, experimenting to see which directions would work best and offer the most to tribal artists. In addition to printmaking, there were a variety of programs, ranging from workshops in traditional art forms and professional development to photography, book arts, papermaking, and computer skills. Eileen Foti came out from Rutgers to conduct workshops and to work with Lavadour and other artists (fig. 5).

In September 1997, five years after its founding, the new Crow's Shadow facility was formally dedicated. It included a spacious printmaking studio, offices, a darkroom, and a gallery. The stage was set for making CSIA a center for printmaking, but other events had begun to intervene. For the next few years, CSIA was kept busy with projects that, while valuable, had not been anticipated in its carefully formulated five-year plan.

The opening coincided with a request from the new Tamástlikt Cultural Institute, CTUIR's cultural center and museum, for works—traditional arts—to sell in their store. Even more critical, though, was an urgent need to serve students, as monies for the arts in education had dried up in the Pendleton school district and elsewhere. Understaffed and underfunded, Crow's Shadow tried to fill that gap—and that impacted the development of the printmaking program. Printmaking took second place to an assortment of workshops and other projects, not all of which had clear connections to either Indigenous arts or to Crow's Shadow's core mission or, for that matter, adequate funding. And, while some of these collaborations were successful and attracted mainstream attention, Crow's Shadow found itself perceived as an ad hoc arts and crafts center, serving not only students from the reservation but also from Pendleton schools and programs for at-risk youth. As a reporter for the *Confederated Umatilla Journal* (which has consistently covered events and developments at Crow's Shadow) noted, "Between 1995 and 1999, Crow's Shadow was developing youth-oriented projects, some with small contracts that paid less than half the actual expenses, and others without any financial support

(below) Figure 6. Tim Rollins in the studio, 2000.
Photo: Walters Photographers.

(below) Figure 6. Tim Rollins in the studio, 2000.
Photo: Walters Photographers.

and still others with a few generous one-time-only grants from national or regional foundations."[7]

Among the high points of those years was a weeklong workshop with the New York–based artist and teacher Tim Rollins, who began his innovative programs for youth in the 1980s. With his K.O.S. (Kids of Survival), Rollins has made collaborative works of art based on (and often literally collaged onto the pages of) classics of literature that run the gamut from Nathaniel Hawthorne's *The Scarlet Letter* to Ralph Ellison's *Invisible Man* to the plays of Shakespeare. Rollins and an assistant came to CSIA in the summer of 2000. In the space of a week, he led more than a dozen students in reading and memorizing passages from *A Midsummer Night's Dream* and then translated Shakespeare's words into a collage of brilliantly colored, hand-painted flowers, adorned with beads (fig. 6).

A TURNING POINT

Despite the critical acclaim for events such as Rollins's visit, Lavadour and the board felt that the organization

needed to get back on track and to refocus on fine arts. In 1999, under the leadership of then executive director Donna Milrany, Crow's Shadow applied for and received a planning grant from the Meyer Memorial Trust, based in Portland. Their funding and support gave the board and staff the resources to regroup and craft a five-year plan. They resolved that Crow's Shadow should define itself as a printmaking studio first and foremost, and that hiring a full-time resident master printer was essential. Going back to the early discussions about place and mission, they agreed that the printmaking studio should be open to Native and non-Native artists alike, to facilitate cultural exchanges. While there were no plans to discontinue traditional workshops, they would be more thoughtfully organized. Careful fundraising strategies would be used to secure more stable sources of income. Finally, the gallery space, which had hosted several community exhibitions, would be used to display prints produced at Crow's Shadow.

Two important steps toward realizing these goals were taken in 2001. The first, "Conduit to the Mainstream," was an ambitious three-day symposium organized by CSIA

Figure 7. Participants in the Conduit to the Mainstream symposium, September 2001. Left to right: Anthony Dieter, Joe Feddersen, Truman Lowe (seated), Margaret Archuleta, Eileen Foti (on table), James Lavadour, Marjorie Devon, Laura Recht, Dr. Rennard Strickland, Frank Janzen, Kay WalkingStick (seated), Edgar Heap of Birds, Prudence F. Roberts, Mari Andrews (seated), Joanna Bigfeather, James Luna, and Marie Watt (seated). Photo: Walters Photographers.

and supported by the Paul G. Allen Family Foundation of Seattle and the nonprofit, Art:21, founded in 1997, whose films, videos, and books make the work of contemporary artists accessible to mainstream audiences. In early September, Native American artists, curators, and scholars came to Crow's Shadow to discuss the state of the arts in Indian Country and to formulate strategies through which Crow's Shadow could truly help emerging artists enter the mainstream (fig. 7). Participants included pre-eminent Native American artists and academics: scholars Dr. Jackson Rushing and Dr. Rennard Strickland (Osage/Cherokee), artists Joanna Bigfeather (Cherokee/Mescalero Apache), Joe Feddersen (Colville Confederated Tribes), Edgar Heap of Birds (Tsistsistsas/Cheyenne), Truman Lowe (Ho-Chunk), James Luna (Luiseño), Kay WalkingStick (Cherokee), and Marie Watt (Seneca), as well as Tamarind Institute Director Marjorie Devon, Mari Andrews of Crown Point Press, and Rutgers' Eileen Foti. The symposium served not only to give CSIA board and staff myriad ideas about moving the organization to the next level, but it also brought the organization itself to the attention of a larger art community. Devon subsequently arranged a collaboration between Tamarind and Crow's Shadow, selecting

six emerging Native American artists, three of whom would work at Tamarind, and three—Larry McNeil (Tlingit/Nisga'a), Ryan Lee Smith (Cherokee/Choctaw), and Steven Deo (Muscogee Creek/Euchee)—at Crow's Shadow. The six artists' works were exhibited in *Migrations*, which opened in September 2007 at the University of New Mexico Art Museum, with an accompanying volume of essays edited by Devon.[8] Feddersen, Lowe, Luna, WalkingStick, and Watt were among the artists who came back to work at Crow's Shadow in the following years.

The second piece of the puzzle fell into place when CSIA hired Canadian Frank Janzen, an artist and Tamarind-trained master printer, shortly before the Conduit to the Mainstream conference.[9] Janzen's presence was a clear signal that Crow's Shadow had returned to its original mission and was poised to become one of the few fine-art presses in rural communities in the United States, with an emphasis on lithography (fig. 8).

Eileen Foti was a member of the search committee that selected Janzen. She had marveled over the years at Lavadour's tenacity and vision and his generosity with

his own time, money, and talents. In the early years, she had come to Crow's Shadow several times, to work with Lavadour on the first of the many print editions he regularly makes to raise funds for Crow's Shadow. She also collaborated with Rick Bartow (Wiyot, b. 1946) and Joe Feddersen, artists she knew and respected. Like Lavadour, each had received an NEA fellowship to work with her at Rutgers. Foti remembers a printmaking workshop open to the public at CSIA in the early 1990s. Its success deepened her conviction that Crow's Shadow occupied a unique and necessary niche. She had expected a dozen or so participants, not the forty-four who showed up to make art that weekend, standing three-deep around the tables, waiting their turn at the press.

When Crow's Shadow decided to refocus on printmaking, Foti served as an informal consultant, helping to review plans to complete and upgrade the print studio, providing it with a proper layout, new equipment, and ventilation systems. Again, Lavadour's vision and determination to make a facility that was not just adequate, but superlative, impressed her. "I would have done anything for them," she said.[10]

Thus, Janzen walked into a functioning studio in 2001, even if some basic supplies were lacking in those early days. Ironically, the prints Janzen made with his first resident artist proved to be among the most challenging of his sixteen-year tenure. Edgar Heap of Birds, renowned artist, political activist, and University of Oklahoma art professor, had come to Pendleton for the Conduit to the Mainstream conference and stayed on to work at CSIA. Janzen had not yet officially begun his job; he and his wife Marie had just arrived in Oregon and were still in the process of settling in. As Janzen recalls, the studio had not been used in recent days and lacked many basic supplies. Heap of Birds envisioned a complex, eighteen-color lithograph (page 87). To realize his conception, Janzen had to search around for supplies since the print required twelve plates to produce all eighteen colors. Keiko Hara at Whitman College in Walla Walla, Washington, helped to find plates, and Janzen was able to track down paper and inks. Because of technical complexities and the disruption wrought by the events of September 11, 2001, Janzen and Heap of Birds finished the edition via email and phone conversations some months later.[11]

CROW'S SHADOW PRESS

Crow's Shadow Press was thus formally established in 2002. Janzen quickly imposed a new level of professionalism and consistency upon print production, documentation, and storage. (Also trained as a finish carpenter, Janzen is as capable of making beautiful frames as he is of functional tables and storage shelves.) As Foti has noted, the editions from Crow's Shadow Press are superlative—as meticulous and as beautifully produced as any in the world. In 2002, ten artists worked with Janzen on lithographs and monotypes. CTUIR tribal members joined such nationally acclaimed Native artists as Philip John Charette (Yup'ik), Truman Lowe, and Marie Watt.

Local artists were involved in an international artistic exchange (one of several over the years with global Indigenous communities) conceived by Eileen Foti, who had been training young printers in South Africa. She invited CSIA to choose five Native American artists to collaborate with five San artists from the Kalahari Desert region in Botswana who were working with Artist Proof Studio in Johannesburg. They produced a print portfolio

entitled *Myth of Creation*, with images and texts inspired by Indigenous creation myths and legends from their various traditions. Phillip John Charette, Jo Motanic Lewis, Jennifer Svoboda (Cayuse/Walla Walla), and Jeremy Red Star Wolf (Nez Perce/Warm Springs/Yakama) each contributed one work to the project. The lithographs were printed and assembled in an elegant box tied with buckskin.

Crow's Shadow's reputation grew as each resident artist came away inspired and energized by collaborating with Janzen, and excited about the prints they had produced. Janzen's knowledge and skills, creativity and energy have won him an international following among both artists and print collectors.[12] Marie Watt (fig. 9), best known for her sculpture and wall pieces in which she works with such symbolically loaded materials as reclaimed blankets, has written eloquently about her experiences at Crow's Shadow Press:

> One way I mark the passage of time in my work and in my career is by my relationship with Crow's Shadow. I have printed with Frank Janzen four times and my fifth will be this fall [2017]. I can't speak of

Frank without acknowledging Marie Janzen (Crow's Shadow's volunteer extraordinaire—CSI errand runner, lead sponger, greeter, occasional cook, and an honorary British granny). At this point, going to CSI seems like a family event.

I've dined at their table, crashed on their couch, and spent long days, nights, and weekends doing the tinkering, pacing, mark-making, toiling at and resolving of plates, not to mention heaps of trial color drawdowns in the name of making prints. Working with a master printer is an intimate experience and Frank's upbeat disposition, great patience, we-can-do-anything attitude ("What do you want to do, kid?"), and vast historical and technical knowledge make him a wonderful collaborator. It's important to note that the job of a master printer is incredibly physical and technical. While Frank started this career late by master printer standards, I suspect he can run the lithography equivalent of laps around a younger generation of printers. All these attributes come together to form Frank Janzen's superpower. Many people have kept Crow's Shadow afloat over the years, but I think Frank's lived experience, steadfast

presence, and belief in CSI's mission have created a unique space of possibility and community for the artists who were invited to print with him.[13]

Crow's Shadow Press has established a program of workshops, training, and residencies. To date, more than forty artists have been awarded residencies with Janzen. Partnerships with other institutions, including the Pacific Northwest College of Art, Whitman College, Linfield College, and Willamette University, have brought hundreds of art students for workshops. The original Ray Trayle press is now in an arts center on the Hoopa Indian Reservation in northern California, thanks to a workshop Janzen led for six students from the College of the Redwoods, who drove ten hours to get to Pendleton, printed monotypes for the better part of a weekend, and slept on the floor of the gallery. After they returned to California, they sold some of the work they produced in order to be able to afford a second trip. Their enthusiasm and talent convinced Janzen to sell them the Trayle press, after The Ford Family Foundation provided the funds to buy a new etching press (fig. 10).

Figure 10. Frank and Marie Janzen with students on the Hoopa Valley
Indian Reservation, Hoopa Valley, California, 2011. Photo: Willa Briggs.

REACHING THE MAINSTREAM AND A NEW GENERATION OF ARTISTS

The Ford Family Foundation of Roseburg, Oregon, is fore-most among the many charitable organizations whose generosity has helped Crow's Shadow over the years.[14] The Foundation, in existence since the 1950s, launched a comprehensive Visual Arts Program in 2010, supporting Oregon artists and arts organizations through strategic programs and grants. Among its objectives is to bridge the urban-rural divide, in a state where the arts receive insufficient recognition or support outside the Portland metropolitan area. In 2011, Crow's Shadow became one of four "Golden Spots," locations in Oregon identified by the foundation as places providing exceptional environments for artistic creativity,[15] and thus eligible to receive annual funds to support three residencies for Oregon artists.

The Ford Family Foundation criteria for choosing Golden Spot awardees—that they be Oregon residents and at mid-career or later—has meant that, in addition to Native artists Brenda Mallory (Cherokee), Wendy Red Star (Apsáalooke), Sara Siestreem (Hanis Coos), and Shirod

Younker (Coquille/Miluk Coos), several non-Native artists have received Golden Spot residencies. While this has represented a departure from the previous emphasis on offering residencies primarily to Indigenous artists, early discussions of Crow's Shadow's mission emphasized cul-tural exchange of all sorts and the importance of bringing a variety of contemporary artists to the local community. Each of the artists in the Golden Spot program has given a public talk and some have participated in workshops during their stay. But more importantly, the prints they have made have been instrumental in propelling regional awareness of Crow's Shadow, thereby benefiting both Native and non-Native artists. As well as Golden Spot residents, there have been a number of prominent Native American artists who have come to Crow's Shadow since 2011, including Corwin Clairmont (Salish Kootenai), John Feodorov (Navajo), Frank La Pena (Wintu), James Luna, and Lillian Pitt (Wasco/Yakama/Warm Springs).

In addition to the Ford Family Foundation, CSIA has recently collaborated with the Roundhouse Foundation in Sisters, Oregon, to offer fellowships to central Oregon art-ists. The goal is to give these participants (there are two in

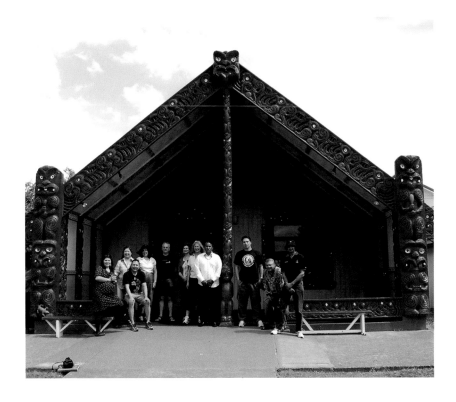

Figure 11. CSIA delegation at Takapuwahia Marae in Porirua City, New Zealand, in 2008. Left to right: Althea Huesties-Wolf, Patrice Walters, Phillip John Charette (seated), Kay WalkingStick, Frank Janzen, Rebecca Dobkins, Raphael Hoffman, Te Taku Parai (Māori), Jeremy Red Star Wolf, and Australian aboriginal artists Danny Eastwood and Jake Soewardie. Photo: Margaret Tolland.

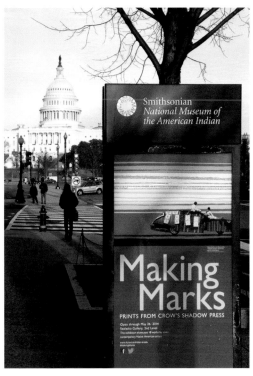

Figure 12. An exhibition banner for *Making Marks: Prints from Crow's Shadow Press*, at the National Museum of the American Indian, Washington, DC, 2014. Photo: Kathleen Ash-Milby.

2017) exposure to new ideas that they can then share with other artists in their communities.

In recent years, print sales have become a significant source of revenue for CSIA, contributing a healthy percentage of the annual operating budget.[16] Sales have been helped by greater exposure at fine-art print fairs in Portland and New York and by a newly revamped website. In addition, museum groups and collectors frequently visit the gallery and it is promoted as a cultural destination by regional tourist bureaus.

Exposure for Crow's Shadow Press and the artists who have worked there has also come through numerous exhibitions. There have been more than forty since 2006, including prominent international and national venues along with smaller, regional galleries. In 2008, the Hallie Ford Museum of Art sent an exhibition, *Crow's Shadow: Prints from Native American Artists* to the Pataka Museum in Porirua City, New Zealand. The project was part of the biennial New Zealand International Festival of the Arts, and a delegation associated with CSIA traveled to the festival to take part in presentations and print- and

paper-making workshops alongside other Indigenous artists (fig. 11). In May 2013, *Making Marks: Prints from Crow's Shadow Press*, opened at the Smithsonian Institution's National Museum of the American Indian's George Gustav Heye Center in New York, with eighteen prints by Rick Bartow, Phillip John Charette, Joe Feddersen, Edgar Heap of Birds, James Lavadour, Wendy Red Star, and Marie Watt. It subsequently traveled to the Smithsonian's National Museum of the American Indian in Washington, DC.[17] In 2014, the IAIA Museum of Contemporary Native Arts in Santa Fe hosted *ARTiculations in Print-Prints from the Crow's Shadow Institute of the Arts*. In 2015, the Eiteljorg Museum worked with Crow's Shadow to present *New Art 2.0*, a selection that included both Native and non-Native artists (fig. 13).

Exhibitions have also led to sales. The Whitney Museum of American Art recently acquired a lithograph by Edgar Heap of Birds. In 2015, the Library of Congress, in Washington, DC, acquired eighteen prints. In its press release, CSIA quoted Katherine Blood, Curator of the library's Fine Arts, Prints, and Photographs Division: "This acquisition represents a wonderful enrichment to

Figure 13. Students from Nixya'awii Community School at Crow's Shadow, May 23, 2017. Left to right: EllaMae Looney, L'Rissa Sohappy, Sunshine Fuentes, Tyanna Van Pelt, and Helena Peters. Photo: Nika Blasser.

the Library's extensive holding of fine prints, bringing first-time representation of work from this important press and an array of notable American artists. Each print represents a triple threat of aesthetic and technical excellence combined with compelling subject matter."[18]

BACK TO EDUCATION

One of Crow's Shadow's most rewarding partnerships of recent years has been an intensive relationship with a small group of high school students at Nixya'awii Community School, a charter school on the reservation focusing on Native American culture, with a strong language component. While Crow's Shadow had worked with the school in its early days, the current program began in 2015, under the leadership of Nixya'awii counselor Michelle Van Pelt. Over the course of the 2015–2016 school year, a small group of students came to Crow's Shadow one or two afternoons a week. Janzen walked them through the printmaking process, from the technical aspects of printing to the creative. By the end of the program, each student had learned the skills to make both linocuts and

photolithographs, and had produced at least one edition of five prints (fig. 13). Prints by each artist were included in an exhibition at Crow's Shadow, installed by the students, who were also responsible for pricing their own work and producing labels. The exhibition then traveled to the Maryhill Museum of Art in Goldendale, Washington. A second show there is scheduled for September 2017.

INDIGENOUS ARTS WORKSHOPS

While they do not command as much external attention as the print studio, workshops for such art forms as cornhusk weaving, twining, beadwork, and the making of various regalia have been a vital piece of Crow's Shadow's identity since the beginning. Patrice Hall Walters, who has never left the board (except to serve as Crow's Shadow's acting Executive Director for two years, from 2001 to 2003), has overseen and organized most of these events. Nearly all are open to the general public, although some are for Native artists only, and most fill almost immediately, often by word of mouth. Some twenty to forty students come together for a two- to three-day intensive

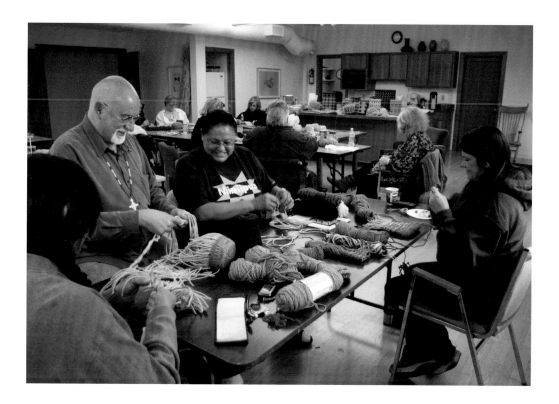

class. As Walters notes, the workshops are important social occasions, rooted in Indigenous culture, and often taught by CTUIR members. Sometimes three generations of a family come to learn—or relearn—a particular skill (fig. 14). Among the instructors have been such important artists as Pat Courtney Gold (Wasco/Warm Springs), CTUIR artists Joey Lavadour, Whitney Minthorn, and Thomas Morning Owl, and Navajo weaver Anita Hathale.

CSIA offers four to six traditional arts workshops a year. Walters believes that number will increase in the future; Nixya'awii Community School will be expanding to offer a twelve-year curriculum and has approached CSIA about facilitating the teaching of Indigenous art forms to younger students.

TWENTY-FIVE YEARS AND BEYOND

The last decade has seen Crow's Shadow take several steps to lay a foundation for its future and for its legacy. Stability seems to have finally arrived for an endeavor that has frequently lacked that luxury but has never considered closing its doors. One of these steps has been the partnership with the Hallie Ford Museum of Art at Willamette University. Under the leadership of its director, John Olbrantz, and curator Rebecca J. Dobkins, the museum has organized biennial exhibitions of prints from Crow's Shadow since 2006.[19] But in 2012, the museum made a further commitment: to serve as an archive for Crow's Shadow Press, thereby making all of its prints available to the public and scholars alike through a dedicated website and regular exhibition schedule, and guaranteeing their preservation for future generations.

Crow's Shadow has found it a challenge to attract and to keep an executive director whose talents and energies could thrive in the small-town setting of Pendleton. Over the years, many directors have not been able to find that footing. In 2014, CSIA hired Karl Davis. Davis had been the director of Froelick Gallery in Portland (its founder Charles Froelick is currently CSIA board President) and holds his MA in Art History from the University of Alberta.[20] His background in administrative work, his knowledge of contemporary art, and his contacts in the art world have served as invaluable assets. Since his

arrival, Crow's Shadow has participated in art fairs, been awarded several new grants, added new board members, and hired its first marketing director, Nika Blasser. An interdisciplinary artist, she has studied printmaking and is also experienced in gallery work: she was the assistant manager at Quintana Galleries in Portland, which has a focus on Northwest Coast Native arts.

Another step has been the creation of CSIA's first endowed fund. Although he never had a formal affiliation with Crow's Shadow, Rick Bartow was a guiding spirit behind the scenes. He was a frequent visitor, making his own monoprints with Janzen and occasionally collaborating with Lavadour. Painter, printmaker, sculptor, and musician, Bartow is among Oregon's best-known and most revered artists (fig. 15), with works held in public collections nationally and internationally. Before his death, he donated all proceeds from sales of his Crow's Shadow prints back to the organization. This act of generosity allowed CSIA to establish The Rick Bartow Endowment Fund at the Oregon Community Foundation. Its proceeds will support residencies for emerging Indigenous artists.

In its press release, CSIA noted, "The fund is a first for our organization; we feel that planting this seed is the best way to honor our friend while creating a long-lasting and stabilizing legacy for our programming."[21]

In its twenty-fifth year, changes are afoot, and Crow's Shadow is receiving accolades and publicity.[22] The board and staff are beginning to explore the possibility of expansion, with the goal of gaining more space for printmaking, classes and the Indigenous arts workshops, more storage facilities, a larger gallery, and accommodations for resident artists. In whatever shape this new center assumes, it will remain, as it is now, deeply grounded in community. And it will maintain the sense of place that makes it magical—and visionary. After sixteen years, Frank Janzen is planning his retirement for late 2017. His successor, Judith Baumann, will begin working with Janzen in the summer of 2017.[23]

In a recent letter of support, Portland City Commissioner Nick Fish described Crow's Shadow as an "Oregon treasure," and wrote that

The Institute showcases Native art, provides economic opportunities in Eastern Oregon, and helps to connect the communities across Oregon, while reflecting the rich history and culture of our region.

The works of art created by affiliated artists, including James Lavadour and Rick Bartow, are displayed in museums and galleries across the country. The City of Portland is proud to have original works produced at Crow's Shadow in its public art collection.[24]

Flash back from that statement to James Lavadour's original dream: to use art as a tool for economic and cultural development for Native American artists. His vision has proven durable, sustainable, and prescient.

SOME KEY DATES IN CTUIR HISTORY

1855 Treaty established the Confederated Tribes of the Umatilla Indian Reservation (CTUIR) on a fraction of the original lands occupied by the Cayuse, Umatilla, and Walla Walla. The Tribes reserved the rights to hunt, fish, and gather on their ceded lands.

1949 CTUIR, with the guidance of a newly hired tribal attorney, narrowly voted to establish a constitutional government with a Board of Trustees and a General Council. Constitution and bylaws were adopted.

1974 Overall Economic Development Plan (OEDP) adopted, focusing on land and water as economic resources and on CTUIR infrastructure.

1988 Salmon return to the Umatilla River, a hard-won triumph after the Tribes' work with regional irrigation departments and the Oregon Department of Fish and Wildlife.

1992 Crow's Shadow Institute of the Arts is founded.

1995 Wildhorse Casino and Resort opens; Wildhorse Foundation created in 2001, with funds dispersed through donations to Tribal development and grants to local programs and organizations.

1998 Tamástlikt Cultural Institute opens.

Acknowledgments

This brief history is informed by many hours of great conversations with wonderful people. Foremost, of course, is Jim Lavadour, who first told me his ideas for an art institution back in 1992. I thought then that if anyone could pull it off, he was the man. I am grateful to Pat Walters for so much—her generosity, intelligence, and kindness have been a godsend. Eileen Foti gave me invaluable information about the early days of Crow's Shadow and her belief in Jim's vision. Thanks to Marie Hall and Raphael Hoffman for the memories and insights they have shared with me. Tom Hampson suggested some fascinating avenues to explore. I appreciate Antone Minthorn's succinct account of recent Tribal history and Father Mike Fitzpatrick's description of Crow's Shadow's relation with St. Andrew's. Karl Davis and Nika Blasser have been so gracious with time and resources. And while I cannot improve on Marie Watt's praise of Frank and Marie Janzen, I can add my heartfelt thanks to them both. Thanks also go to Rebecca Dobkins for her invaluable help and suggestions, and to John Olbrantz for being patient.

NOTES

1 www.pdxmonthly.com/articles/2017/1/23/this-pendleton-institute-is-a-beacon-for-native-art (accessed 4-1-2017). Fiona McCann.

2 Crow's Shadow Institute of the Arts was incorporated in 1992 by James Lavadour and his then-wife JoAnn Lavadour.

3 Foti in conversation with the author, April 4, 2017.

4 Foti, April 4, 2017.

5 Interestingly, St. Andrews Mission has been home to printmaking enterprises before: In 1971, it housed Pi-Em-Nat Enterprises, "a youth silk-screening business" (as mentioned by Roberta "Bobbie" Conner, in *Wiyaxayxt / Wiyaakaa'awn / As Days Go By: Our History, Our Land, Our People* (Pendleton, OR: Tamástlikt Cultural Institute; Portland, OR: Oregon Historical Society, 2006), 228.

6 *Arts East* Eastern Oregonian Arts Council, Winter 1994, n.p.

7 "Crow's returning to original mission," *Confederated Umatilla Journal*, June 7, 2001, p. 17.

8 Marjorie Devon, ed., *Migrations: New Directions in Native American Art* (Albuquerque, NM: University of New Mexico Press, 2006), includes Gerald McMaster's "Crow's Shadow: Art and Community," a brief history of CSIA and its impact.

9 Tamarind Institute, affiliated with the University of New Mexico, Albuquerque, was founded in Los Angeles in 1960 with the goal of reviving lithography. Each year, a very few apprentices are chosen to complete the rigorous training that leads to Master Printer certification.

10 Foti, April 4, 2017.

11 A print from this edition is now in the collection of the Whitney Museum of American Art.

12 Among the artists who have written about the importance of their time at Crow's Shadow are Daniel Duford, ("A Fellowship with the Land. *High Desert Journal*, Spring 2013: 24–30), and Wuon-Gean Ho ("Matters of Life and Death," *Printmaking Today* 15(2) Summer 2006: 25).

13 Email exchange with the author, April 13, 2017. Watt has referred to herself as the Crow's Shadow "poster child," acknowledging its role in creating "significant experiences and opportunities" in her career, from the Conduit to Mainstream event in 2001 to the present day. See Watt's statement in Rebecca J. Dobkins, *Marie Watt: Lodge* (Salem, OR: Hallie Ford Museum of Art, 2012), 32.

14 Grants have come from several sources, ranging from the Bureau of Indian Affairs and the Northwest Area Foundation to the Flintridge Foundation, Wildhorse Casino, the Oregon Arts Commission, the Oregon Community Foundation, and the Meyer Memorial Trust.

15 The other Golden Spots are Caldera, an innovative art-based program for underserved youth, which also hosts artists in residence during the winter months at its campus near Sisters, Oregon; Leland Iron Works (at Pacific Northwest College of Art, Portland), and Playa, an artists' residency in Summer Lake.

16 Artists receive fifty percent of the revenue, once production costs are covered.

17 The National Museum of the American Indian has recognized CSIA's importance not only in exhibitions, but also in its publication, *American Indian*. Anya Monteil's "Making an Impression: Crow's Shadow Institute of the Arts" appeared in its Fall 2011 issue (pages 42–47). See www.academia.edu/28859985/_Making_an_Impression_Crow_s_Shadow_Institute_of_the_Arts._ (accessed 4-4-2017).

18 Crow's Shadow Institute of the Arts, "Library of Congress makes Major Purchase from Crow's Shadow," July 6, 2015. See http://crowsshadow.org/event/library-of-congress-makes-major-purchase-from-crows-shadow/ (accessed 4-4-2017).

19 Lois Allan's review of the first Biennial ("'Crow's Shadow Institute Biennial' at Hallie Ford Museum of Art") appeared in the now-defunct *Artweek* 38(1), Feb 2007: 24–25.

20 Davis wrote a brief history of Crow's Shadow to accompany *Remote Impressions: Works from Crow's Shadow Press*, an exhibition at Portland State University's Broadway Lobby Gallery in Lincoln Hall. *A Brief History of Crow's Shadow* was published in the exhibition brochure (Portland, OR: Portland State University, College of the Arts, 2016).

21 Crow's Shadow Institute of the Arts, "Announcing the Rick Bartow Memorial Endowment Fund," July 12, 2016. See http://crowsshadow.org/events/event/rick-bartow-memorial-endowment-fund-established/ (accessed 4-4-2017).

22 These include proclamations from CTUIR and the City of Portland as well as essays and acknowledgments.

23 Baumann completed Tamarind's Professional Printer Training Program in 2015 and received her MFA in printmaking from Virginia Commonwealth University, School of the Arts, Richmond, Virginia, in 2005.

24 Portland City Commissioner Nick Fish, letter to Ms. Eleanor Sandys, Oregon Arts Commission, nominating Crow's Shadow for the Governor's Arts Award, June 30, 2017.

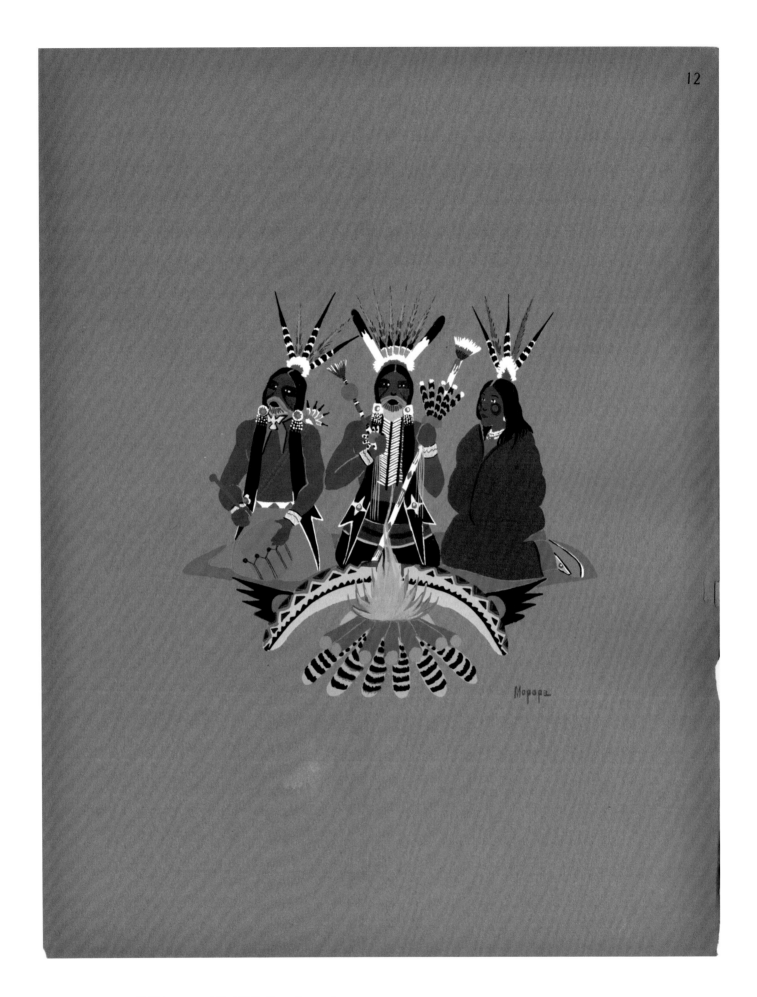

Figure 1. STEPHEN MOPOPE (Kiowa, 1898–1974), *Kiowa Singers*, from
the Kiowa Indian Art Portfolio, 1929, ed. 750, pochoir (screenprint),
15 x 11½ in., Fred Jones Jr. Museum of Art, University of Oklahoma,
Norman; Gift of Elaine Bizzell Thompson, 1998. Photo: Fred Jones Jr.
Museum of Art, University of Oklahoma, Norman.

THE EMERGENCE OF INDIGENOUS PRINTMAKING IN NORTH AMERICA

heather ahtone and Rebecca J. Dobkins

In 1992 when James Lavadour (Walla Walla, b. 1951) and friends established Crow's Shadow Institute of the Arts, they created a visionary space for Native American artists to engage with lithography and other creative activities, seeding economic and artistic benefits in the local community and well beyond. Crow's Shadow has created significant artistic connections between Indigenous and non-Indigenous communities through a medium—printmaking—that resonates with Native principles of reciprocity and facilitates long-distance exchange. In this essay, we situate CSIA as part of a grand artistic tradition engaged in by Native hands for at least a century.[1]

Printmaking has a long and storied history as an art form found in cultures across the globe. Early examples include the cylindrical stone seals used for printing by the Sumerians in Mesopotamia as early as 3500 BC, the development of woodblock printing in China during the Han Dynasty (pre-220 AD) and later in Japan, and the well-documented emergence of woodblock and other forms of printing in Europe in the fifteenth century. In the Americas, the Olmec of Mesoamerica used cylindrical seals for printing on cloth as early as 650 BC, and the existence of the Adena tablets suggests that there were forms of printing in the Ohio Valley as early as 800 BC–1000 AD.[2]

During the European colonial expansion period, the medium was used for mass publication of images for nonliterate populations and for reproduction of paintings before the photographic age.[3] At the end of the nineteenth and beginning of the twentieth centuries, lithographic posters were one of the most readily available art forms in global urban spaces, from the art posters made by Henri de Toulouse-Lautrec (1864–1901) for the Moulin Rouge in Paris in the 1890s to the social protest prints made by Diego Rivera (1886–1957) and other Mexican artists during and after the Mexican Revolution of 1910–20. Lithography, which allowed for the mass production of single artworks, ushered in a democratization and decentralization of the art world.[4]

In considering printmaking within Indigenous communities as a form of creative expression, however, one must understand how paper—the material upon which images are made in most printmaking—has historically

31

functioned as a weapon of domination and power over Native peoples. The convention of recording treaties and other legal edicts on paper was imposed upon Indigenous communities and contributed to rendering them subject to Western legal cultural standards on their own lands. Thus, since contact, paper has facilitated the dispossession of tribal lands, rights, and languages. Yet from the ledger drawings created by incarcerated Plains artists in the nineteenth century to prints made by Indigenous artists through a variety of processes today, Native Americans have taken paper, a weapon so often used against them, and turned it into a tool for what Gerald Vizenor calls *survivance*: "an active sense of presence, the continuance of native stories, not a mere reaction, or a survivable name. Native survivance stories are renunciations of dominance, tragedy and victimry."[5] In this light, Indigenous printmaking is evidence of survivance, a visual affirmation of the cultural vitality with which Native communities have emerged into the twenty-first century.

So, with this backdrop, how did the medium of printmaking come to Indian country? In the post-World War II era, printmaking has become associated with specific Indigenous arts communities, such as those of the Inuit and the Pacific Northwest, as well as with educational institutions and print centers in Oklahoma and the Southwest, such as the University of Oklahoma, the Institute of American Indian Arts, and Tamarind Institute. In addition, many Native artists work as instructors of printmaking in university art programs in the U.S., nurturing new generations of Indigenous artists. This essay provides an overview of the development of printmaking among Indigenous artists in North America, and explores the networks of relationships that continue to ignite interest in the varied processes collectively referred to as printmaking. We see how, in turn, this history intersects with and informs that of Crow's Shadow.

OSCAR JACOBSON AND THE OKLAHOMA ARTISTS

One of the first instances of printmaking to have a significant impact on Native American artists and the public reception of their art was the publication, beginning in 1929, of several portfolios featuring Native American art and imagery (fig. 1) by a small fine-arts press in Nice, France, owned by C. Szwedzicki.[6] Oscar Jacobson, director of the University of Oklahoma's art program from 1915 to 1954, edited three of the six portfolios, in 1929, 1950, and 1952.[7] Using art made by Native Americans in portfolios that were then circulated internationally, Jacobson had an acute awareness that these portfolios served to introduce contemporary Native American art to a global market. Describing Jacobson, who was trained at Yale, Janet C. Berlo writes that "Jacobson's devotion to contemporary American Indian painting of his era is well-known to scholars of Native art, for he provided Oklahoma Native artists with opportunities for education, income, and exhibition across the United States and Europe, and published portfolios of reproductions of Native art that were sought after by collectors."[8] Jacobson's well-documented interest in Native American culture played an important role in his agreement to work with five Kiowa artists at the university. Spencer Asah (1905–1954), Jack Hokeah (1902–1973), Stephen Mopope (1898–1974), Lois Bougetah Smoky (1907–1981), and Monroe Tsatoke (1904–1937) were

identified through their art teacher at the St. Patrick's Mission School in Anadarko, Oklahoma, for further formal training, and they arrived on campus in Fall 1926.[9] Their art—as well as that of James Auchiah (1906–1974), who came to OU in 1927—was the sole source for the 1929 portfolio, *Kiowa Indian Art*. Through the broad dissemination effected by this portfolio, Jacobson and the Kiowa artists became foundational to what became known as the Plains Indian style of painting. The portfolio of thirty plates in an edition of 750 was printed using original gouache paintings as sources and reproduced using the pochoir process, one of the highest forms of quality fine-art printing at the time. Pochoir requires each image to be deconstructed into a series of hand-cut stencils, one for each color, used to reproduce the plates manually. The publication of the portfolio in 1929 both built upon and increased international interest specifically in the Kiowa artists, whose work by that time had been exhibited in Chicago, Denver, and New York. During the 1920s–1940s, both an interest and a market were developing for American Indian painting through exhibitions such as *Indian Art of the United States*, at the Museum of Modern Art in New York in 1941, which both reflected and helped generate patronage of contemporary Native arts.[10]

Two decades after the 1929 Kiowa portfolio, Jacobson's 1950 portfolio, *American Indian Painters*, is a two-volume, seventy-seven plate set featuring reproductions of artwork by notable Plains and Southwest artists, most of whom were associated with the University of Oklahoma or with the Studio School at Santa Fe Indian School started by Dorothy Dunn in 1932. Published using serigraphy instead of the earlier pochoir method employed in the

1929 Kiowa portfolio, *American Indian Painters* reflects changes in printmaking technology that resulted in part from the influence of the Federal Arts Project of the Works Progress Administration (1938–45), whose Graphic Arts Division emphasized printmaking, particularly serigraphy, as a democratizing art form.[11] Serigraphy uses a frame with stretched silk mounted to the front as the matrix (thus the term silkscreen). The screen is treated, often with photo emulsion, rendering it into a stencil form after exposure to light. The ink is pressed through the fine weave and lays flat on the receiving surface. As with pochoir, a separate screen is used for each color, but the level of detail and the refinement of the lines are significantly improved over the pochoir process.

Most of the artwork reproduced in the 1950 portfolio was known to scholars, curators, and collectors of the time as "traditional" Native American painting. These paintings often featured an isolated figure or figures engaged in cultural practices familiar to the artist and drawn from memory. With the successful publication of the 1950 portfolio, which quickly sold out to collectors and institutions, many Native artists became acutely aware of the advantages offered by printmaking as a medium for the marketing of their imagery.[12]

Among those included in the 1950 volume who became interested in exploring the potential of printmaking were Harrison Begay (1917–2012) and Gerald Nailor (1917–1952), Navajo artists based in Santa Fe, New Mexico. The same year, 1950, that Jacobson published *American Indian Painters*, Nailor and Begay established Tewa Enterprises in Santa Fe as a serigraphy print shop

for Native artists. This was an important moment for the Native artists who were asserting their artistic hand in the printing process. Begay and Nailor developed an extensive body of serigraphs from this period. The images were generally translations of their paintings into the medium. Most Native artists working in printmaking, like Begay and Nailor, had received some kind of formal training and were directly involved in the art market. Though the Tewa Enterprises print studio ceased operation after a few years, printmaking was on its way to becoming more important in the broader Native arts community.[13]

Under Jacobson's direction, from 1915 to 1954, the OU School of Art introduced other Native artists to printmaking, including Acee Blue Eagle (Muscogee Creek/Pawnee, 1907–1959), Woodrow "Woody" Crumbo (Muscogee Creek/Potawatomi, 1912–1989), and Cecil Murdock (Kickapoo, 1913–1954), all significant figures in twentieth-century contemporary Native fine arts. Jacobson's role as the Oklahoma agent for the WPA kept the state apprised of developments emerging for printmaking as a medium. Courses in printmaking were incorporated into the School of Art's curriculum. With formal exposure to multiple printmaking processes, the Native graduates' work as printmakers was important not only for their own art, but also for the influence they were to have as instructors teaching in institutions with large Native student populations.

The printmaking department at the University of Oklahoma went through major growth under the guiding hand of Emelio Amero (1901–1976), a Mexican-born artist, who arrived in Norman in 1946. As a member of the populist art movement in postrevolutionary Mexico, Amero had developed a personal style emphasizing full, blocky figures similar to those of Diego Rivera. In Mexico, Amero had established a lithography workshop and taught printmaking in the national school of fine art,[14] before moving to the U.S. in the 1930s, where he taught at the Florence Cane School of Art and worked as a WPA muralist in New York City. Eventually, he took the position at OU, where he taught until his retirement in 1968, and is credited with building the program into a regionally important printmaking center. During his tenure, Amero worked with many Native students, including Dennis Belindo (Kiowa/Navajo, 1938–2009), Oscar Howe (Yanktonai Dakota, 1915–1983), and Chief Terry Saul (Choctaw/Chickasaw, 1921–1976).

Dennis Belindo's *Kiowa Blackleggins* is an illustration of the power of the medium of printmaking in the hands of Native artists (fig. 2). Belindo's image makes visual references to the Kiowa traditions of pictorial art through the figure of the dancer at the Black Leggins Society. The Ton-Kon-Gah, one of the Kiowa Tribe's six traditional warrior societies, wear the red cape as an important symbol of membership. The battle tipi in the background recognizes warriors who made the supreme sacrifice.[15] This image, made in the 1990s, was a personal statement by Belindo, who was a member of the esteemed society. He wasn't romanticizing history; he was evoking the emotions of his own experiences of the dance and using a modern medium to speak to his modern experience. He took advantage of the characteristics of serigraphy and used them to greatest effect in the creation of an image speaking to cultural identity. Serigraphy is particularly suited

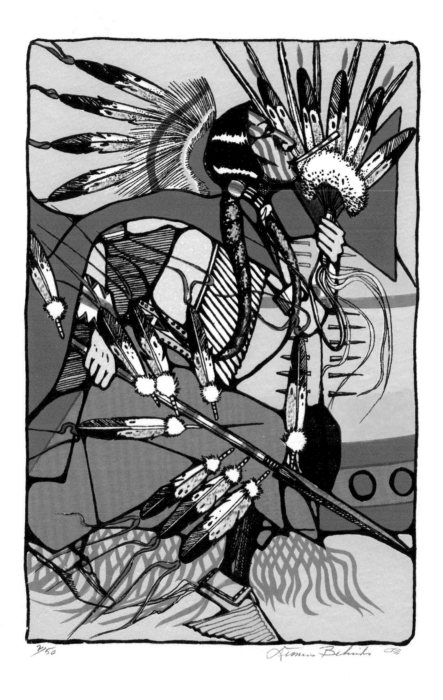

1/50 *Jimmie Belindo*

to large color fields, the use of a black outline, and a simplified palette. This image has only six colors: pink, white, flesh tone, yellow, gray, and red. But through its careful organization, the image fully activates the entire composition with the diagonals of the lance and the feathers against the red flow of the cape into the tipi structure.

By the time Belindo graduated with a Bachelor of Fine Arts degree from the University of Oklahoma in 1962, instruction in printmaking had expanded, along with U.S. universities themselves, under the post-World War II G.I. bill. During the same period, an emphasis on handcrafted art perhaps ironically accompanied the era's rapid technological developments.[16] In the 1950s and 1960s, several ateliers, or print workshops, were established to save lithography from its perceived "extinction" in North America, and to provide training for new generations of master printers, including the Tamarind Lithography Workshop in 1959–60 (which later became Tamarind Institute at the University of New Mexico in

Albuquerque).[17] Simultaneously, outside of cosmopolitan centers, Native artists began to find printmaking relevant to their art practice. One of the most significant stories is that of Canada's Inuit community.

INUIT COOPERATIVE PRINTMAKING STUDIOS

The Inuit have a long history of applying and incising imagery on clothing, tools, and implements, as well as of tattooing and sculpting practices. However, they have a limited history in the creation of two-dimensional art and, in fact, the closest experience for the Inuit with two-dimensional art may be scrimshaw and drawn maps, learned from the influx of foreign whalers and explorers in the mid-nineteenth century. A few communities, like the Copper Inuit, were adopting the practice of drawing on paper by the late nineteenth century, but this practice did not spread extensively across the Arctic region. Inuit artistic traditions were not significantly changed until the mid-twentieth century, when the Canadian artist and federal government administrator James Houston arrived at Inukjuak, northern Quebec, in the late 1940s to prepare a series of drawings on the Inuit and the Arctic landscape. There, he traded some of his drawings for Inuit soapstone carvings, which he took back to Montreal for gallery display and sale.[18] Initially, Houston served as a conduit for a market based on the sculptures he collected and showed to peers at the Canadian Handicrafts Guild.[19]

After contributing to the development of an international market for Inuit carving, Houston introduced printmaking to Inuit artists in the late 1950s, who by then were familiar with graphic design in the form of advertisements. In 1958–59, Houston traveled to Japan for three months to study woodblock and stencil printmaking and brought these lessons back to Cape Dorset. Inuit artists improvised upon Japanese techniques, initially using stone from local sources as a matrix instead of wood, employing their already well-developed stone-carving skills. Houston emphasized the Japanese *ukiyo-e* process, involving collaboration between artist and master printer. Houston believed a collaborative environment could create multiple roles that would support a new economic stream for Inuit people.

It is important to note that printmaking in Inuit communities was an externally imposed means of economic development intended to reduce the welfare burden on the state. Inuit communities suffered extreme disruption of their traditional lifeways during Canada's colonial expansion in the North, much of which was still unfolding in the mid-twentieth century. Forced relocation into village settlements and the related interruption of subsistence practices contributed to Inuit dependency on the Canadian government. Though the Inuit were interested in printmaking as a means toward self-sufficiency, the print studios required the development of an Inuit aesthetic and artistic perspective that did not previously exist. Scholars Janet Berlo, Nelson Graburn, Heather Igloliorte, and Norman Vorano have further explored the cultural and artistic implications of the co-ops on the cultural identity of the Inuit people.[20]

By 1958 Cape Dorset established a co-operative, eventually (by 1961) named the West Baffin Eskimo Cooperative,

and in 1959 released its first print edition. The co-op established an economic model later followed at other Inuit studios, where an individual Inuit artist and co-op member makes a drawing that is in turn bought by the co-op. Then, as Berlo describes: "A group of people, made up of Inuit co-op members and non-Native advisers, decides which drawings will be chosen as the basis for a stone-cut, silkscreen, lithograph, or other type of print. Usually about forty of these prints, in runs of fifty per image, form the yearly edition of prints for a community."[21] The marketing division of the co-op then promotes and sells the prints in the global art market; for example, Dorset Fine Arts is the marketer for artwork produced through the West Baffin Eskimo Cooperative, which is now commonly referred to as the Kinngait Studio or Co-op, reflecting the Inuit name for Cape Dorset.

In the decades since the 1960s, other co-ops with print-making studios operated across the North, in what is now Nunuvut, Nunavik (northern Quebec), and the Northwest Territories; communities that continue to produce regular print editions with distinctive characteristic styles include Baker Lake, Holman, and Pangnirtung.[22] Through the co-ops, printmaking and sculpture, among other art forms, have become an important economic source of income that enables Inuit families to remain in their communities.

The West Baffin or Kinngait Studio expanded its repertoire of techniques from stonecut and stencils to include lithography and intaglio methods (especially etching and aquatint, a process that approximates the appearance of ink-wash drawing). While the public perception may be that

Cape Dorset arts have sprung out of isolation, southern printmakers and artists have made frequent trips to the north since the 1970s so that artistic exchange has been constant.[23] Inuit artists have consistently embraced the introduction of new methodologies and indigenized them.[24]

In the early days at Cape Dorset, Pitseolak Ashoona (1904–1983) and Kenojuak Ashevak (1927–2013) were daily visitors, helping to establish the Kinngait Cooperative as one of the most productive studios. These artists quickly earned international recognition. The annual Cape Dorset editions were readily transformed into a commodity that would significantly contribute to an expanded market for Inuit art across Canada and western art markets more generally.

Many of the early images were very spare illustrations of the natural environment and daily practices. Kenojuak Ashevak's birds were fluid and evocative images from her memory. The palette may have been limited, but the illustrations dynamically depicted the animals and environment and Inuit cultural stories. Ashevak's stonecut *Enchanted Owl* (1960) became an icon of Inuit art (fig. 3), and the artist printed continuously with the Kinngait Cooperative until her passing.[25]

Initially, Inuit artists were encouraged to express their personal experience and cultural knowledge. Encouragement to create images about traditional culture was an ironic shift away from the assimilationist policies the Inuit had endured for several decades. However, the first generation of artists had living memory of their traditional cultures, and were able to create images that met the market's

Figure 3. KENOJUAK ASHEVAK (Inuit, 1927–2013), *Enchanted Owl*, 1960, stonecut, 21⅛ x 26 in., Brooklyn Museum; Gift of George Klauber, 1998.122. © Kenojuak Ashevak, courtesy of Dorset Fine Arts. Photo: Brooklyn Museum.

(opposite page) Figure 4. SHUVINAI ASHOONA (Inuit, b. 1961), *Scary Dream*, 2006, lithograph, 37 x 32 in., Fred Jones Museum of Art, University of Oklahoma, Norman; The James T. Bialac Native American Art Collection, 2010. Reproduced with permission of Dorset Fine Arts. Photo: Fred Jones Jr. Museum of Art, University of Oklahoma, Norman.

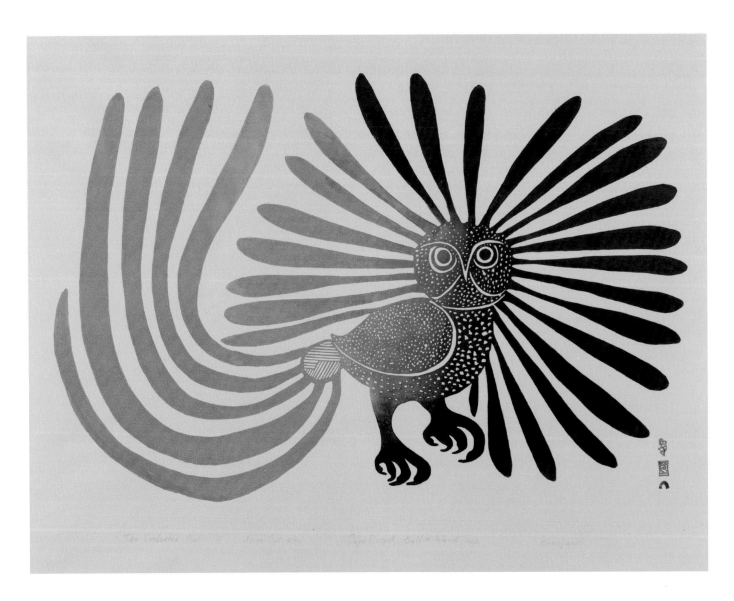

appetite for the exoticism of "Eskimo" life.[26] Until the 1970s, most Inuit artists emphasized single-subject, traditional imagery, which the collecting public had come to expect of Inuit arts. Pudlo Pudlat (1916–1992) was among the first to incorporate images of the changing technological and cultural realities in the North and the first Inuit artist to be featured in a one-person exhibition in 1990 at the National Gallery of Canada. Within two generations, fewer artists had living knowledge of traditional culture as a result of federal impositions against cultural practices. Images emerging out of the Inuit studios continued to focus on personal experience, but no longer looked "purely" Inuit, reflecting the pervasive cultural and technological shifts that had occurred.

In the decades following 1990, other Inuit artists more intentionally took up contemporary subjects. In the 1990s, Napachie Pootoogook (1938–2002), who had been printing with Kinngait Cooperative since 1960, began work on a series of drawings that depicted darker subject matter and personal struggles.[27] Her daughter Annie Pootoogook (1969–2016) followed in her steps to become the "foremost chronicler of contemporary life in Cape Dorset" particularly through drawings that depicted a direct, unflinching, and often humorous account of life in the North.[28] This is evident in *The Homecoming*, where Pootoogook is no longer depicting the outdoor, icy world of the Eskimo. Nature has fallen away as a primary subject and is replaced by the environment of a hospital

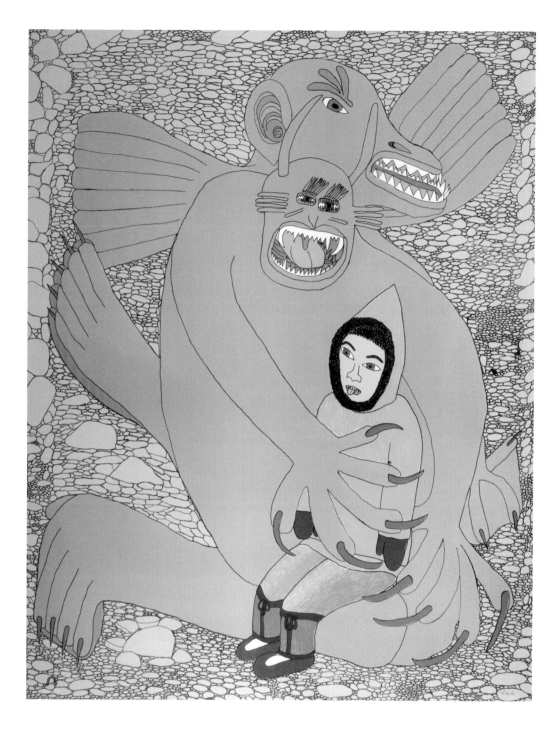

waiting room. Some people continue to wear the *annuraaq*, or traditional skin garments, but others are wearing jeans and jackets. These images of modernized Inuit life were met with some concern by the market; in fact, there was a push to return to the "traditional" images of Inuit experience. The artistic response to this pushback has been mixed. There are still artists and studios focusing on the "traditional" scenes, but most of the working artists have never lived in an igloo, having grown up with television and processed food imported from southern Canada as much as with seal hunts and fishing.

Nevertheless, artistic interest in depicting traditional Inuit stories, which have survived despite political impositions,

has continued unabated. In *Scary Dream*, by Shuvinai Ashoona (b. 1961), the palette has become more complex, the figures are no longer in undefined spaces (fig. 4). The sea monsters are playing with a child who has wandered too close to the shoreline against the admonitions of his parents. Unlike the images drawn from memory, Ashoona's subjects are pure imagination, constructed from listening to the stories as they've been passed down and combined with a hint of 1970s cartoons. Ashoona and Pootoogook represent another characteristic of the Inuit co-ops. These cousins are the third generation of Inuit printmakers to transform printmaking from an externally dictated economic device into a medium that helps them to produce important records of Inuit life. Inuit

Figure 5. ROBERT DAVIDSON (Haida, b. 1946), *Beaver*, 1974, ed. 287,
serigraph, 16 x 14 in., George and Colleen Hoyt Collection.
Photo: Dale Peterson.

RD 74 Robert Davidson 93/287

graphics can also be credited for the establishment of a significant market for printmaking in Canada. As artists from the lower latitudes watched the flow of Inuit graphics through galleries, the interest of other First Nations artists followed.

CANADIAN STUDIOS OUTSIDE OF THE ARCTIC

Across Canada, printmaking activity was growing and becoming more accessible to First Nations artists. Silkscreen printing has been part of Northwest Coast graphic arts since the 1940s, when Ellen Neel (Kwakwaka'wakw, 1916–1966) first created formline designs on cloth.[29] In the 1950s and 1960s, Northwest Coast artists engaged in a revival of traditional carving, painting, and weaving. This exploration created a

rich environment in which printmaking could thrive. Northwest Coast designs lent themselves to graphic arts, and silkscreen printing was an easily accessible method. Many artists had been exposed to serigraphy through training at art schools such as the Emily Carr Institute (now University) of Art and Design in Vancouver. Robert Davidson (Haida, b. 1946), a key figure in the Northwest Coast carving renaissance, began printmaking in 1968 (fig. 5). Open Pacific Graphics (now Pacific Editions Limited) was established in 1968 by a group of artists from Northwest Coast communities as a commercial print studio in Victoria. In 1977, a group of artists founded the Northwest Coast Indian Artists Guild, which particularly promoted graphic arts and sought recognition of Indigenous design.[30] The portability and affordability of prints, when compared to that of large-scale wood carvings, met with great enthusiasm in Canadian

and U.S. art markets at a time when Indigenous arts were highly sought after. This popularity in turn spread an awareness of Indigenous graphic design and iconography that continues in the Northwest Coast today.[31]

Within these Native-operated initiatives, artists were given the freedom to work in the style they felt best suited their ideas, sometimes merging traditions with contemporary evocations. A tradition for working with serigraphy evolved from the images prepared at Pacific Editions Limited and other small studios. Adapting the formlines of sculpture to the carefully organized color fields of serigraphy, George Hunt, Jr. (Kwa-guilth, b. 1958), attested to the value of printmaking as a process that helped develop his ideas as he continued working in traditional sculpture.[32] He explained that he could experiment with image composition in a serigraph and then, if he liked it, put it to use in

the more arduous process of carving. If the image did not present as he expected it to as a drawing, he knew before he started cutting the wood.

For many artists from the Kwakwaka'wakw and other Northwest Coast tribal communities, printmaking became a secondary outlet for their creative work. Because carving plays such an important role in the region, it remains a primary artistic medium. However, aesthetic knowledge about cultural figures translates easily into printmaking and is an alternate source of income and expression. In *Thunderbird and Sisuilte*, Jonathan Henderson (Kwakwaka'wakw, b. 1969) shows the dynamic relationship between these two ancient creatures from whom many of the Kwakwaka'wakw clans are descended (fig.6). While it may be subtle, Henderson has borrowed a compositional format from the Kwakwaka'wakw architecture

found in Northwest Coast longhouses that is perfectly suited to the rectangular shape of the paper's image area.

Susan Point (Musqueam, b. 1952) began her career as an artist by making jewelry and prints on her kitchen table in 1981. Point turned to carving, initially one of the few Northwest Coast women to do so, and in recent decades has designed monumental public art projects. Inspired by Coast Salish spindle whorls, Point frequently works with circular shapes, and her *Completing the Circle* (1992) additionally references women's creative power (fig. 7). She is perhaps the most prolific printmaker among Northwest Coast artists, and through both prints and sculptural work has contributed to the contemporary vitality of Coast Salish art.[33]

There are many contemporary artists from Northwest Coast communities who today work in print, including those who have extended their subject matter beyond traditional legends. One such example is Lawrence Paul Yuxweluptun (Cowichan/Okanagan, b. 1957), a painter who also works in print. His well-known screenprint, *Clear Cut to the Last Tree*, of 1993, like others by Yuxweluptun, is constructed from a synthesis of Northwest Coast forms, Surrealism, and landscape painting to express concerns with environmental and cultural degradation.

Across Canada, in the province of Ontario, Norval Morrisseau (Sand Point Ojibwa, 1932–2007), from Thunder Bay, Ontario, and his relatives in nearby Red Lake, had a similarly related impact in the development of Indigenous printmaking. Morrisseau was raised by his maternal grandparents, who trained him in the traditional cultural knowledge of the Ojibwa Midewiwin Society. Artistic since his childhood, Morrisseau is credited with

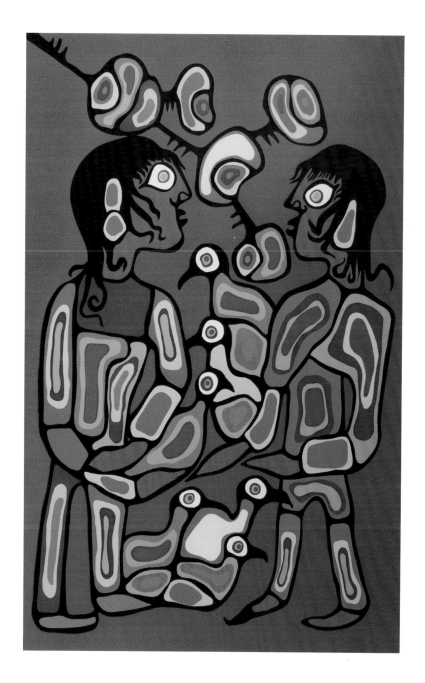

establishing the Woodlands Style characterized by color fields bounded by bold black outlines and influenced by traditional Ojibwa beadwork and birchbark illustrations. By the 1950s, a following developed for Morrisseau's paintings and initially he created images that referenced his tribal knowledge. He came to be heavily criticized by his own community for revealing traditional knowledge to the non-initiated public, for whom that knowledge was considered dangerous. However, Morrisseau understood his images to be heavily coded and mixed with his personal style, and believed that his artwork gave life to Woodlands traditions, drawing in a younger generation for whom the culture may have felt outdated (fig. 8).

In 1973, Morrisseau's brothers-in-law, Joshim, Henry, and Goyce Kakegamic, formed Triple K Cooperative, a Native-owned serigraphy studio, in Red Lake. Borrowing the format of the Inuit co-operatives, the three brothers fostered serigraphy as a medium for several of the Woodland School artists. Triple K (which closed in 1980) had an enormous impact on the capacity of artists from the region to produce images through printmaking which, as the Inuit had found, promoted a cultural vision of their world and reengaged a younger tribal community audience with the otherwise threatened cultural knowledge.

Another key figure in Canadian First Nations printmaking was Daphne Odjig (1919–2016), of Potawatomi and Odawa descent. As a founder in 1973 of the Professional Native Indian Artists Association, or the "Indian Group of Seven," Odjig was a painter and printmaker. The same year, Odjig founded Odjig Indian Prints, a small press and gallery in Winnipeg, to further her own work and that of other Native artists.[34]

INSTITUTE OF AMERICAN INDIAN ARTS AND SANTA FE STUDIOS

In the mid-twentieth century, at about the same time Inuit people were establishing lithography studios in the late 1950s and early 1960s in Canada, a new center for Native arts education and production was being formed in the United States. The Institute of American Indian Arts (IAIA) was established in 1962 on the campus of the Indian School in Santa Fe, New Mexico; it initially offered a high school program, eventually expanded to offer postgraduate art courses, and, by 1975, a two-year degree program. In 2000, after a move to a new campus, it developed additional four-year degree programs, including Creative Writing, Studio Arts, and Museum Studies.[35] Founding leadership included administrator Lloyd Kiva New (Cherokee, 1916–2002) and instructors Allan Houser (Chiricahua Apache, 1914–1994), Fritz Scholder (Luiseño, 1937–2005), and Charles Loloma (Hopi, 1921–1991). These visionaries, who each used printmaking methods in their own art, wanted to create a space for Native students to achieve academic success while developing as contemporary artists.

In 1963, IAIA Fine Arts Chair Seymour Tubis (U.S., b. 1919) established a printmaking program. This early presence of a printmaking curriculum meant that generations of emerging Native American artists received crucial exposure to the medium at formative periods in their careers. Though most of the founding faculty at IAIA were recognized Native artists, non-Native Tubis was brought in to set up the printmaking studios. A painter trained at Temple University Museum School and at the Art Students League in New York, Tubis had also been a student of the influential twentieth-century artists Hans Hoffman and Georges Braque. Tubis established a formality in the printmaking studios, where he encouraged students to refine their printing skills while developing their artistic voice. The former IAIA student and retired printmaking professor, Linda Lomahaftewa (Hopi/Choctaw, b. 1947), remembers that the students spoke very highly of him and wanted to take his courses.[36]

As primary teaching roles began to be assumed by Native artists, the IAIA printmaking program remained strong. Tubis was followed by Craig Locklear (Lumbee, b. 1954) who taught from 1981–1988, when he left IAIA to work with the Bureau of Indian Affairs museum programs; now retired, he continues working as a printmaker in his studio in Santa Fe.[37] Jean LaMarr (Pit River/Paiute, b. 1945) taught at IAIA from 1987 to 1992. While an undergraduate at Berkeley in the 1970s, LaMarr was inspired by California's Chicano mural and printmaking movement, and embraced printmaking as a vehicle for political art. LaMarr founded the Native American Graphic Workshop in 1986, on her home reservation, the Susanville Rancheria in northeastern California, before teaching at IAIA. LaMarr's 1989 Cover Girl series utilized printmaking to reclaim images of American Indian women; LaMarr also contributed mixed-media sculptures to the seminal *Indian Humor* (1995) traveling exhibition. Succeeding LaMarr in 1992 was Melanie Yazzie (Navajo, b. 1966), whose career is described below and who taught printmaking at IAIA until her departure in 1999. Since 1999, the IAIA program has been led by a variety of instructors, notably Norman Akers (Osage, b. 1958) and Lomahaftewa, both painters

Figure 9. LINDA LOMAHAFTEWA (Hopi/Choctaw, b. 1947), *Stickball Player*, 2008, mixed media monotype on canvas, 18 x 36 in. overall, J. W. Wiggins Contemporary Native American Art Museum, University of Arkansas, Little Rock. Photo: J. W. Wiggins Contemporary Native American Art Museum.

who are drawn to the creative processes involved in printmaking (fig. 9). Most recently, Neal Ambrose-Smith (Salish Kootenai/Métis-Cree/Shoshone-Bannock, b. 1966) has provided leadership to a vibrant program that continues to nurture new talent.

The studios at IAIA and the other local educational institutions remained the primary source of printmaking in Santa Fe until 1982, when Ron Pokrasso established the Graphics Workshop that operated until 1993. Pokrasso then transferred the equipment and studios to the College of Santa Fe. Under the direction of Don Messec, the Printmaking Studio at the College of Santa Fe became a significant point of production for many of the Native artists in the area until the college closed in the late 2000s.[38] Another important Santa Fe workshop, Hand Graphics, was opened by Ron Adams in 1974, and continues to be an important place for artists to produce work, including Emmi Whitehorse (Navajo, b. 1957).

TAMARIND INSTITUTE

Perhaps the most significant site for printmaking in the Southwest is the Tamarind Institute. Initially founded as the Tamarind Lithography Workshop in 1960 in Los Angeles with the purpose of bringing greater recognition to and appreciation for the art of lithography, Tamarind has had a profound influence in the world of printmaking. Under the direction of founding director June Wayne and with funding from the Ford Foundation, the institute established various long-term goals to train master printmakers and promote lithography in the United States. Pursuing these goals, Tamarind became an innovative and stimulating space for the cultivation of the medium, providing artists who primarily work in other media the opportunity to develop refined images in collaboration with master printmakers.

Ten years after its founding, Tamarind moved to Albuquerque, New Mexico, and became the Tamarind Institute, a new division in the College of Fine Arts of the University of New Mexico. The first Native American artist invited to work at Tamarind after the move was Fritz Scholder, who began working with lithography in 1970 after being sought out by then-director Clifford Adams. He would go on to do at least one series at Tamarind each year from 1970 to 1983.[39]

Many of Scholder's images draw ironically from historic photography by non-Native photographers, especially those that have contributed to the myths and stereotypes surrounding Native American culture. He often borrowed stylistically from painters recognized in the art-historical canon, such as Francis Bacon (British, 1909–1992) and Maynard Dixon (U.S., 1875–1946), to draw attention to his own subversive portrayal of historically accepted representations of Native subjects. In *Noble Indian After Dixon*, Scholder borrows the composition of Maynard Dixon's *The Medicine Robe* from 1915 (fig. 10). The original painting places the male figure atop a ridge with the light coming from behind. Scholder takes advantage of the lithographic process to reverse the light, the composition, and, in doing so, inverts the romanticization of Native people.

In a lithograph printed at Tamarind Institute in 1978, *Dancers at Zuni*, Scholder flipped the negative image of a photograph made by Adam Clark Vroman, *Rain Dance Ceremony* (fig. 11), who in 1899 was working for the Bureau of American Ethnology (now part of the Smithsonian Institution). Scholder cleverly repositioned the central figure to return the viewer's gaze. In this work, Scholder's use of lithographic processes has become more aggressive, as the color areas would have necessitated multiple stones to produce the edition.

Since Scholder's first visit in 1970, Tamarind has periodically hosted Native artists and has had, in the words of scholar Kathleen Stewart Howe, a "quiet commitment" to Native American artists.[40] In the 1970s, R. C. Gorman (Navajo, 1931–2005) visited Tamarind several times, as did the painters Patrick Swazo Hinds (Tesuque Pueblo, 1929–1974), T. C. Cannon (Kiowa/Caddo, 1946–1978), and between 1978 and 1981, Dan Namingha (Hopi, b. 1950).[41] Mixed-media artist and painter Jaune Quick-to-See Smith (Salish Kootenai/Flathead, b. 1940) began printing at Tamarind in 1980, and has completed more than thirty projects in over a dozen visits to the Institute, creating an important body of work that offers insight into her entire artistic career. The Native artists who printed with Tamarind in these early decades were invited in part because they were already, or had the potential to be, commercially successful. It was not until the late 1990s and 2000s that Tamarind expanded its focus and began to work with a wider range of Native American artists.

The 1999 exhibition, *Multiple Impressions: Native American Artists and the Print*, featured work by more than two dozen artists who printed at Tamarind between 1970 and 1999, and was curated by University of New Mexico art historian Joyce Szabo.[42]

Of all the Indigenous artists who have worked at Tamarind, Jaune Quick-to-See Smith has been the most prolific. *In the Future* from 1995 represents Smith's highly charged criticism of the west's cultural treatment of Native Americans, using iconic references to childhood items and science (fig. 12). Smith references Mendel's Rule of Dominance, which explains that hybrid genetic pools would only exhibit the dominant trait in genetic crossbreeding, through the use of repeating pea plants and diagrams. The red rabbit serves as a metaphor for indigeneity, suggesting that crossbreeding will still result in the stronger trait of "being red." This complex lithograph includes multiple layers of imagery as the

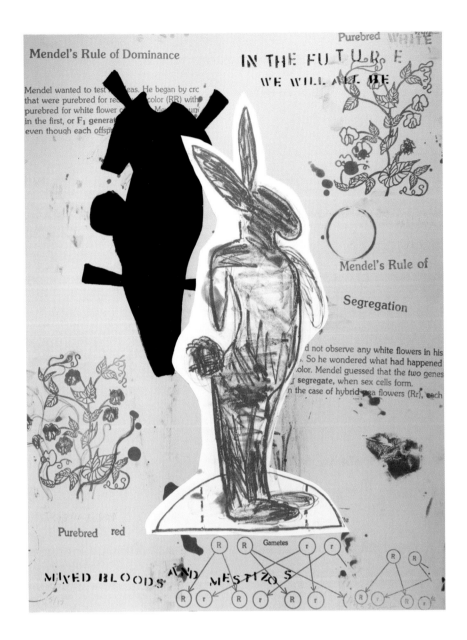

backdrop for the chine collé applied rabbit. Chine collé is a process in which one sheet of paper is physically bonded to another through the use of wheat paste in the printing process.

Other Native American and First Nations artists have printed at Tamarind since 1992, including Robert Houle (Saulteaux, b. 1947), Duane Slick (Meskwaki/Ho-Chunk, b. 1961), and Emmi Whitehorse, who has visited several times since 1994. Whitehorse has experimented with the print process, for example, flipping the paper on the last run of *Silent Rain* (2000) so that the colors, still brilliant, bleed through to produce a muted sense of her desert home landscape (fig. 13).

Tamarind prides itself on a tradition of bringing together artists from diverse cultural and geographic backgrounds to experience the collaborative dimensions of lithography. Since 1999, Tamarind has sponsored four group-portfolio

projects that involve Indigenous artists: the *Trickster Suite* (1999), the *Migrations* project (2004), the *We Are All Knots* portfolio (2007), and the *LandMarks* project (2013). The *Trickster Suite* brought together four Pueblo artists with four artists from the Kalahari San people in South Africa for a two-week exchange. The artists spent the first three days in northern New Mexico Pueblos, then the rest at Tamarind in Albuquerque, producing sixteen prints. The Pueblo artists included Mateo Romero (Cochiti Pueblo, b. 1966) and Felice Lucere-Giaccardo (Keres, b. 1973), both of whom incorporated stenciled and written words into their prints, and Nora Naranjo-Morse (Santa Clara Pueblo, b. 1953) and Diane Reyna (Taos Pueblo, b. 1953), whose images draw upon Southwestern rock art.

Tamarind's influence was seminal in shaping the print-making program at Crow's Shadow Institute of the Arts, which opened in 1992, and the two institutes' collective interest in lithography has been important to

promoting the medium among Indigenous artists globally. In September 2001, Marjorie Devon, the director of Tamarind Institute from 1985 to 2016, attended the Conduit to the Mainstream symposium at CSIA, designed to bring emerging and senior Native artists together with curators and master printers. That same year, Frank Janzen, a master printer who had trained at Tamarind, began his tenure at Crow's Shadow, further embodying an intersection between the two print institutes' histories. The aim of the Conduit symposium was to strategize about overcoming barriers to Native artists' access to mainstream art institutions and critics. One outcome was the *Migrations* project, a joint effort between Tamarind and CSIA, in which Native American emerging artists were nominated for 2004 print residencies at either studio. Tom Jones (Ho-Chunk, b. 1964), Star Wallowing Bull (Ojibwe/Arapaho, b. 1973), and Marie Watt (Seneca, b. 1967) printed at Tamarind, while Larry McNeil (Tlingit/Nisga'a, b. 1955) and Ryan Lee Smith (Cherokee/Choctaw,

b. 1972) printed with Frank Janzen at Crow's Shadow. Uniquely, Steven Deo (Muscogee Creek/Euchee, 1954–2010) printed at both studios. The *Migrations* project produced a book that included an essay by Cree artist and curator Gerald McMaster about Crow's Shadow and a traveling exhibition that juxtaposed each artist's prints with his or her work in other media, showing the power of printmaking to extend an artist's efforts in sculpture or painting or mixed media.[43] In the print *Native Epistemology* (page 104), Larry McNeil combines words and images, as he does in his first medium of digital photography, to pointedly satirize white perceptions of the Indian through the voice of Native characters (in this case, Tonto).

In 2007, the National Museum of the American Indian sponsored the *We Are All Knots* project at Tamarind, named after a print in the portfolio by Jaune Quick-to-See Smith, *We Are All Knots in the Great Net of Life*, 2007. Other artists who printed at Tamarind for this project include

Norman Akers and Mario Martinez (Yaqui, b. 1953), who were printing at Tamarind for the first time, and Marie Watt and Larry McNeil, who had participated in the *Migrations* project. The resulting portfolio was assembled as a traveling exhibition for the U.S. State Department's Art in Embassies program and has been seen on several continents. Akers's *All Things Connected* (2007) utilizes images drawn from his Osage heritage, superimposed upon a background that suggests at once a net and a map of the intersecting roads and highways of contemporary Oklahoma.

In 2013, Tamarind's *LandMarks: Indigenous Australian Artists and Native American Artists Explore Connections to the Land* project brought together Indigenous artists from the two continents "to work as a community, share experiences and artistic styles, and explore a common spiritual connection to the land."[44] Native artists from the U.S. and Canada, Chris Pappan (Kaw/Osage/Cheyenne River Sioux, b. 1971), Jewel Shaw (Cree/Metis, b. 1975), Marie Watt, and Dyani Reynolds White Hawk (Sicangu Lakota, b. 1976), worked alongside Australian aboriginal artists, first in the renowned Yirrkala community of northern Australia and then at Tamarind. In Australia, the artists did woodblock printing and etching and also spent time collecting bark and ochres used as natural paints, to learn about the famous bark painting traditions of Yirrkala. At Tamarind, the artists worked with master printers and students to explore lithographic processes, some for the first time. The project was supported in part by the National Endowment for the Arts.

OTHER GLOBAL INDIGENOUS PRINT COLLABORATIONS

Because printmakers, unlike painters or sculptors, have the ability to make multiple originals relatively inexpensively with material that is much easier to transport, they can more easily share their work. This has facilitated the emergence of print exchanges, a collaborative form of engagement where an artist/curator invites artists to submit an edition of a particular number. Each participating artist receives a complete set of the exchange prints for their own use, with the curator receiving at least one additional set that is often used for exhibition. Most print exchange projects revolve around themes or technical challenges and result in portfolios that can be exhibited in multiple locations. Not long after Tamarind's *Trickster Suite* exchange between Pueblo and South Africa San artists, Crow's Shadow also engaged in international print exchanges. The first such exchange, in 2002, was the *Stories of the Living Land* portfolio. This project was a thirty-seven artist print exchange involving twelve Australian aboriginal artists studying printmaking at Western Sydney Institute of the Arts, Sydney, New South Wales, twelve Umatilla Reservation secondary students who printed at Crow's Shadow under the guidance of master printer Frank Janzen, and twelve students from the Institute of American Indian Arts who printed with instructor Deborah Jojola (Isleta Pueblo/Jemez Pueblo, b. 1962).[45] Artists responded with images that reflected their relationship to the land as contemporary Indigenous people (fig. 14).

The second exchange, the *Myth of Creation* portfolio, also in 2002, was a collaboration between the Artist Proof

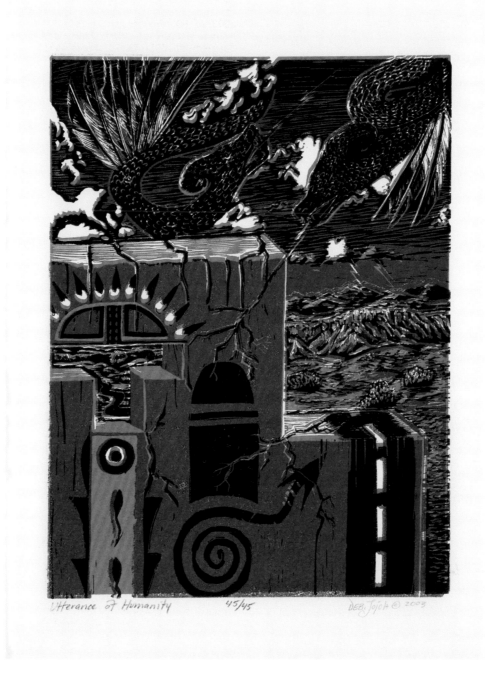

Utterance of Humanity 45/45 DEB Jojola © 2003

Studio (APS) in Johannesburg, South Africa, Center for Innovative Print and Paper at Rutgers University in New Jersey (now the Brodsky Center for Innovative Editions), and Crow's Shadow. It asked artists to explore the theme of creation, in order to celebrate the connections as well as distinctions between peoples of the world. Five San artists from the Kalahari Desert region in Botswana were invited to APS to tell their creation stories and then make lithographic images based on these myths. Simultaneously, five Native American artists, from different tribal affiliations, were invited to do the same at CSIA. Accompanying stories were screen-printed on cornhusk and cotton rag paper made in Johannesburg and the title page was printed at Rutgers (fig. 15).

These print exchanges at Tamarind and Crow's Shadow are among many international artistic exchanges that have taken place in the Indigenous world since the 1990s. Though facilitated by the technological trappings of modernity, these exchanges draw upon well-established cultural protocols and have been perceived by many Indigenous peoples as a healthy reanimation of the kinds of intercultural encounters occurring in precolonial and early colonial times. The introduction of printmaking as a conduit to such exchanges has both opened new doors and produced invigorating visual discourse about contemporary Indigenous experiences.

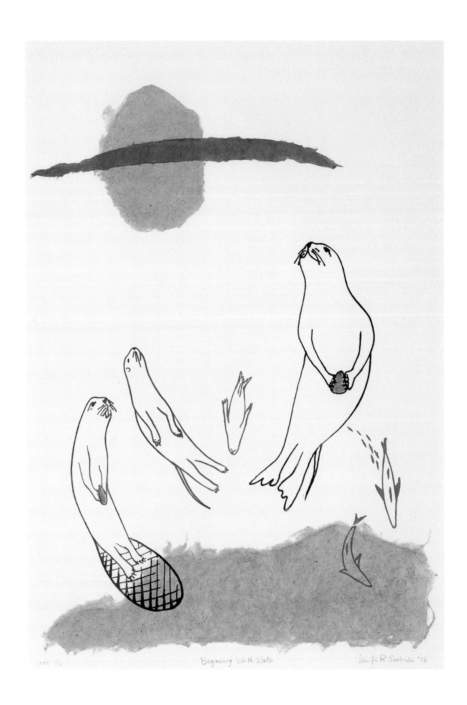

A MATRIX OF INSTRUCTORS AND INDEPENDENT ARTISTS

In addition to the print centers and institutes discussed so far, college and university fine-arts programs in the U.S. have played a role by hiring Native American artists as instructors of printmaking in the decades since 1990.[46] Through their teaching, the field of Native printmaking has grown exponentially. These instructors remain active as professional artists and often are highly regarded because of their commitment to their personal creative vision and their dedication to cultivating new generations of artists. The following discussion selectively profiles printmakers who have held college and university positions teaching printmaking and is organized by the birth year of the artist.

Corwin (Corky) Clairmont (Salish Kootenai, b. 1946) received his BFA from Montana State University and MFA from California State University, Los Angeles, and taught first at the Otis School in southern California before returning to Montana in 1984 to establish the arts department at the Salish Kootenai College. Inspired by Joseph Beuys (German, 1921–1986) and John Baldessari (U.S., b. 1931), among others, Clairmont considers himself an installation and action artist and views the exhibition as a weapon for change. In the 1990s, Clairmont turned to printmaking. With the impending bicentennial commemoration of the westward journey of Lewis and Clark, Clairmont in 2001 began a print series titled *10,000 Years Indigenous People, 200 Years Lewis and Clark.* Later in the decade, Clairmont coordinated an influential

print portfolio project *Native Perspectives on the Trail: An American Indian Print Portfolio*, organized by the Missoula Art Museum in 2005. Fifteen artists were invited to submit images that responded to the mainstream perception of Lewis and Clark as heroic explorers and conquerors.[47] The artists printed with Clairmont at Salish Kootenai College print studios, or with Joe Feddersen (Colville Confederated Tribes, b. 1953) at The Evergreen State College. The resulting exhibition traveled widely and has an accompanying catalogue. Clairmont, who was awarded an Eiteljorg Fellowship for Native American Art in 2003, was in residence at CSIA in 2012 (page 73).

Lynne Allen (Standing Rock Sioux descent, b. 1948), the recipient of numerous awards and fellowships, is highly regarded in the global print world. Director of the School of Visual Arts at Boston University from 2006 to 2015, Allen was a professor of art at Rutgers University from 1989 to 2006 and Director of the Rutgers Center for Innovative Print and Paper from 2000 to 2006. Before coming to Rutgers she was a master printer and educational director at Tamarind Institute, and received her MFA from the University of New Mexico in 1986. In 2002, Allen inherited her grandmother's possessions, an event that led the artist to explore further her family history. Allen's great-grandmother was a member of the Standing Rock Sioux of South Dakota, and was sent to Carlisle Indian School, which began a process of multigenerational assimilation that in a sense produced Allen. The artist interrogates this history in many works, including *My Winter Count* (2001), a print that uses a timeline of shoes

to portray the troubled transition from her great-grandmother's life to her own.[48]

Joe Feddersen taught art full-time from 1989 to 2009 at The Evergreen State College, influencing over two decades of students, including Melissa Bob (Lummi, b. 1982), who was interim director of Crow's Shadow Institute of the Arts in 2011–12. Feddersen has methodically explored the processes and techniques of printmaking since his first exposure to the media in the early 1970s.[49] Trained under Glen Alps (U.S., 1914–1996), one of the twentieth century's most important print artists, at the University of Washington in the 1980s, Feddersen later received his MFA from the University of Wisconsin in 1989. While at Evergreen, Feddersen began the Plateau Geometrics series, at once a celebration of the possibilities of printmaking and of the abstract graphic designs of Plateau iconography. *Okanagan II* (2002), a monumental installation of eighty-four separately printed panels, combines a variety of techniques (woodcut, relief stencils, and siligraphy, a type of waterless lithography), and employs Plateau basket designs with names like butterfly, mountain, and pit-house. The related Urban Indian series (beginning in 2002) is a wide-ranging body of work from prints to weavings to glass that references urban design elements (such as chain-link fences and tire treads) as well as Plateau designs—themselves abstracted from the Indigenous landscape. Much of Feddersen's work since that time continues this playful yet challenging trajectory, in which the artist combines contemporary landscape design elements, such as electrical towers (fig.16) and

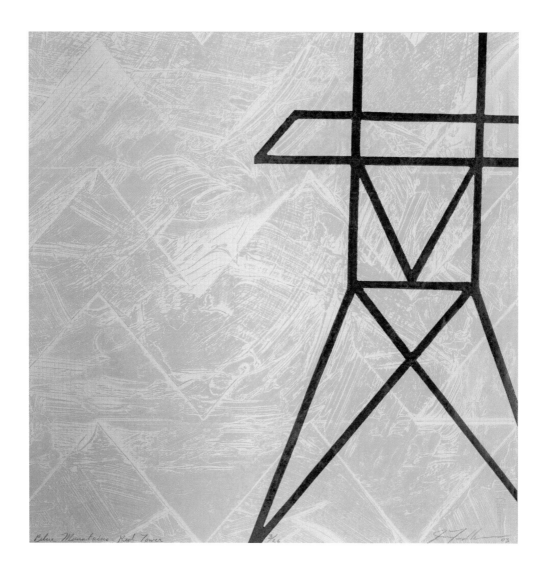

Blue Mountains - Red Tower 36 '03

parking lots, with traditional Plateau patterns to render the Indigenous visual vocabulary visible and shatter dichotomies between past and present. Feddersen's *Wyit View* (2003) is one of the lithographs that has become most associated with Crow's Shadow (page 79). In *Wyit View*, he used a cul-de-sac diagram overlaid with traditional migration designs borrowed from baskets to address the relationship between migration and suburban development. The title, *Wyit View*, refers to a proposed federally funded housing development on the Umatilla Reservation at which ancestral remains were found; the Tribes chose not to disturb the remains and returned the federal monies at a time when such funds were sorely needed, a decision whose integrity Feddersen wished to acknowledge with this artwork.

Melanie Yazzie (Navajo, b. 1966) has been a veritable force in the international printmaking community. She considers her teaching role to be as significant as her

artistic production, and while she has remained committed to working with members of her Navajo Nation, she has broadened the scope of the community with whom she works to include international sites. In 1995 Yazzie traveled to New Zealand as a guest artist to work with Toi Māori, the national Māori arts organization, and has worked collaboratively with Indigenous artists from Australia, Canada, Mexico, and elsewhere, through travel and international print exchanges. After teaching at IAIA, she went on to teach printmaking at her alma mater, the University of Arizona, and since 2006 has been teaching at the University of Colorado at Boulder, where she is head of the print studio. Yazzie's evolving imagery reflects her personal and cultural visual idioms as well as borrowings from the several Indigenous communities with whom she has worked. While the palette is light and colorful, the use of positive and negative space speaks to the complexities involved with remaining culturally grounded through ceremony, ritual, and language, despite personal

hardships. She plays with scale and layering to interweave these symbols into a hopeful message for continued cultural identity. Yazzie printed at Crow's Shadow in 2012 (page 137).

John Hitchcock (Comanche/Kiowa descent, b. 1970) is a print and installation artist who has taught since 2001 at the University of Wisconsin, Madison, School of Art, which houses one of the best-regarded graduate printmaking programs in the U.S. Hitchcock earned a BFA (1990) at Cameron University in Lawton, Oklahoma, and a MFA (1997) at Texas Tech University. As one of the most radically experimental printmakers working today, Hitchcock comes to the print world with a commitment to social and political commentary shared with many other printmakers, past and present. Growing up with his Native mother and white father in Oklahoma, Hitchcock was raised literally across the road from the massive Fort Sill military base, yet within his extended Comanche family's tribal lands. Hitchcock's work critiques the militarization and violence at the heart not only of contemporary American society but also of its imperial past. His major installation *Epicenter* (2011) investigates the dislocations and losses of war, both natural and social. *Epicenter* combines prints installed on the walls, print cutouts on the floor, and printed felt banners hanging from flagpoles, along with three video components.[50] *Epicenter* was first shown in the United States and then traveled to the 54th Venice Biennale, where it became *Epicentro: ReTracing the Plains*, a print action staged in conjunction with the Dirty Printmakers of America, in which prints were made and

distributed in a traditional give-away. Very much identified with an international community of printmakers, Hitchcock has traveled and exhibited across the globe.

The paintings of Marwin Begaye (Navajo, b. 1970) came to the attention of a broad audience very early in his career, through IAIA student exhibitions and the *Indian Humor* traveling exhibition, which included *Daydreaming* (1993), a portrait of a Navajo grandmother flying across a blue and white sky with umbrella in hand. After graduating from IAIA in 1994, Begaye went on to receive a BFA in Painting (2003) and a MFA in Printmaking (2006) from the University of Oklahoma, where he is now professor of printmaking and painting. In recent years, Begaye has concentrated upon printmaking as a means to address Native American community problems and to provoke audiences to seek cultural solutions to contemporary issues. The *What's Your Sugar? Diabetes in Indian Country* series was begun in the early 2000s after Begaye's family suffered hardships because of the disease. He has said that woodblock, serigraphy, and graphic design allow him to visually communicate in a very direct, high-impact way. Begaye has also taken on related issues of alcoholism and substance abuse in works such as *Addiction 3* (2011), where he uses a gothic/gang aesthetic popular with many Native youth, and visual puns (drug injection needles form a halo around a skull) to arrest his audience. Begaye's graphic style mimics corporate advertising in a strategy called "Culture Jamming," where icons of corporate culture are turned back on themselves.[51] Begaye identifies colonialism as the source of the current health crisis in

Indian country and simultaneously calls on Native people collectively and individually to take action to combat their own complicity in the situation. Begaye recognizes the importance of his role as a Native art instructor at the same university that fostered Kiowa artists to pursue formal training in the 1920s. OU continues to be an important graduate program for Native artists, many of whom have studied with Begaye.

The School of Art at Arizona State University, Tempe, has also promoted printmaking by Native American artists through its biennial *Map(ing) (Multiple Artists Printing Indigenous and Native Geographies)* residency and exhibition. Established in 2009 by ASU's Joe Baker (Delaware, b. 1946) and project director Mary Hood, *Map(ing)* brings together five Indigenous artists with ten graduate student collaborators to produce limited-edition prints over a ten-day period. Since most invited artists do not have extensive printmaking experience, the graduate students play an important role in facilitating the realization of the artists' visions for their projects. Prints produced at *Map(ing)* have been included in multiple exhibitions and are archived at the ASU Art Museum.[52]

INDIGENOUS PRINTMAKING: INTERSECTIONS AND INSURGENCE

Entire bodies of the work produced at print studios have been organized into repositories, such as the Canadian Museum of Civilization's archive of Inuit prints, the Tamarind archives at the University of New Mexico, and the Crow's Shadow Institute of the Arts archive at the Hallie Ford Museum of Art. These collections provide archival evidence of critical impulses in Indigenous art history distinct from collections of other media such as painting or sculpture that do not share with printmaking the phenomenon of producing multiple originals. These repositories offer access to the development of the ideas and work of individual artists over time and will prove to be significant resources for future Native American art scholarship and practice.

Ironically, in the digital age of the twenty-first century, the craft of printmaking is resurgent. Like digital communications (and in fact fueled by them), printmaking is a vehicle for collaboration, for social and artistic commentary, and for the exchange of ideas and images across national and cultural boundaries. In the broader international context of Indigenous arts, printmaking facilitates collaboration and experimentation that in turn accelerate aesthetic and political developments in both local and global arts communities. As creative actors of survivance, printmakers are contributing to their own tribal communities both through the presence of their art and, for external audiences, as an assertion that they and their work remain validated cultural identities. Through the production of contemporary art, the artists contribute visually to the vitality of exchange and discourse, and—through the work of curators and scholars—toward the creation of scholarship that reflects Indigenous perspectives.[53] Moreover, their images illustrate the complexities of contemporary Indigenous experience. Using paper as a primary tool for printing images, the artists reclaim what

was a weapon of cultural domination and have indigenized it to their own purposes.

While this narrative of the emergence of Indigenous printmaking in North America must necessarily be incomplete, given the dynamic and decentralized nature of printmaking itself, it provides a context for understanding the development of Crow's Shadow Institute of the Arts since 1992, when James Lavadour and his friends envisioned a reservation-based organization to nurture Native artists, and alighted upon the media of printmaking to provide its foundation.[54] Some influences are explicit, such as that of the Tamarind Institute, particularly through the direct impact of administrators and the professionally trained lithographers Eileen Foti, Marjorie Devon, and of course Frank Janzen, the master printer from 2001 to 2017, upon the trajectory of Crow's Shadow. Yet other influences are equally significant if more diffuse. The Indigenous artists in residence over the last twenty-five years have been informed by many elements of this story, whether these arise from the early importance of printmaking as it emerged at the University of Oklahoma, the role of the Institute of American Indian Arts in introducing generations of Native artists to print media, the looming presence of the Inuit and Northwest Coast print traditions, or direct instruction and inspiration offered by the proliferating number of Native artists teaching in university schools of fine arts in the U.S. Each artist in residence brings these influences, as well as those of home and biography, to add to the life history of Crow's Shadow, a history at once singular and profoundly entwined with a wider story of Indigenous printmaking.

NOTES

1 This essay grew out of the dialogue between the authors and our ongoing curatorial practice and scholarship. Dobkins wishes to acknowledge that portions of this essay are based upon a chapter on printmaking written in 2012 for the forthcoming *Native Art Now: Developments in Native American Art*, edited by Veronica Passalacqua and Kate Morris, with an introduction by Kate Morris (Indianapolis: Eiteljorg Museum of American Indian and Western Art, 2017). Ahtone wishes to acknowledge the many artists and collectors who contributed toward her research for *Enter the Matrix*, an exhibition presented by the Fred Jones Jr. Museum of Art, University of Oklahoma, in Fall 2015, which served as a foundation for portions of this essay.

2 David W. Penney, "The Adena Engraved Tablets: A Study of Art Prehistory," *Midcontinental Journal of Archaeology* 5(1) (1980): 3–38.

3 Trudy V. Hansen, *Printmaking in America: Collaborative Prints and Presses, 1960–1990* (New Brunswick, NJ: The Jane Voorhees Zimmerli Art Museum; New York: Harry N. Abrams, 1995), 13–14.

4 Hansen, *Printmaking in America*, 43.

5 Gerald Vizenor, *Manifest Manners: Narratives on Postindian Survivance* (Lincoln: University of Nebraska Press, 1999). Alan Velie has analyzed the term as a portmanteau of "survival and endurance," while Jace Weaver has suggested that it is from "survival and resistance."

6 Janet Catherine Berlo, *The Swedzicki Portfolios: Native American Fine Art and American Visual Culture 1917–1952* (Cincinnati, OH: University of Cincinnati Digital Press, 2008).

7 The 1952 portfolio was *North American Indian Costumes*, a series of fifty plates by a single artist, Oscar Howe, commissioned by Jacobson to depict the diversity of Native dress from 1564 to 1950.

8 Janet C. Berlo, "From Indigenous America to North Africa: The Cosmopolitan World of Oscar Jacobson and Jeanne d'Ucel," in Mark A. White, ed., *A World Unconquered: The Art of Oscar Brousse Jacobson* (Norman, OK: Fred Jones Jr. Museum of Art, 2015), 105.

9 Smoky left the university after a semester for family reasons. She was replaced by James Auchiah.

10 Janet C. Berlo and Ruth B. Phillips, *Native North American Art* (Oxford, UK: Oxford University Press, 1998), 218–220.

11 Gene Baro, *30 Years of American Printmaking* (Brooklyn, NY: The Brooklyn Museum, 1977), 8.

12 Berlo, *The Szwedzicki Portfolios*, 67.

13 Personal conversation between h. a. and James T. Bialac, personal friend of Harrison Begay and Allan Houser, who relayed the importance of Tewa Enterprises to many of the artists who would go on to use serigraphy as an important supplemental income source in addition to the sales of their paintings, April 2, 2015.

14 Alice Lee Parker, "Prints and Photographs," *Quarterly Journal of Current Acquisitions* 10(1) (1952): 45–60.

15 Thanks to Warren Queton from h. a. for his guidance in reviewing these notes on the image by Dennis Belindo, *Kiowa Blackleggins*.

16 Hansen, *Printmaking in America*, 28; and Norman Vorano, *Inuit Prints: Japanese Inspiration: Early Printmaking in the Canadian Arctic* (Gatineau, Quebec: Canadian Museum of Civilization, 2011).

17 Hansen, *Printmaking in America*, 38. For further background on the history of Tamarind Institute, see Marjorie Devon, *Tamarind Touchstones: Fabulous at Fifty* (Albuquerque: University of New Mexico Press, 2010).

18 Dorset Fine Arts, 2016, *Art of Cape Dorset* (Canada), booklet, n.p.

19 This account of the beginning of Cape Dorset printmaking relies upon Vorano, *Inuit Prints: Japanese Inspiration*, 1–11.

20 For further reading on the topic see Janet C. Berlo, "Drawing (upon) the Past: Negotiating Identities in Inuit Graphic Arts Production," in Ruth B. Phillips, ed., *Unpacking Culture: Art and Commodity in Colonial and Postcolonial Worlds* (Berkeley: University of California Press, 1999), 178–193; Nelson H. H. Graburn, "Authentic Inuit Art: Creation and Exclusion in the Canadian North," *Journal of Material Culture* 9(2) (2004): 141–159; Heather Igloliorte, et al., *Decolonize Me* (Ottawa: Ottawa Art Gallery, 2012); and Vorano, *Inuit Prints: Japanese Inspiration*.

21 Berlo, "Drawing (upon) the Past," 180.

22 Other Inuit communities periodically produced prints, including Great Whale River, Inoucdjouac, Ivujivik, and Wakeham Bay. See "About Inuit Prints and Print Making" at www.inuit.net/About-Printmaking.php (accessed 5-26-15).

23 For discussion of the visits of southern artists to Cape Dorset and the resulting mutual artistic influences, see Patricia Feheley, "Tradition and Innovation," in Leslie Boyd Ryan, *Cape Dorset Prints: A Retrospective: Fifty Years of Printmaking at the Kinngait Studios* (San Francisco: Pomegranate Press, 2007), 77–109.

24 Ryan, *Cape Dorset Prints*, 8.

25 John A. Westren, "Toward the Millennium," in Ryan, *Cape Dorset Prints*, 233.

26 The term Eskimo is considered derogatory by many and is used here only to provide context for the market attitudes that informed the artists' work.

27 For an account of Napachie Pootoogook's career, along with that of other Inuit women artists, see Odette Leroux, Marion E. Jackson, and Minnie Aodla Freeman, *Inuit Women Artists: Voices from Cape Dorset* (Ottawa: Canadian Museum of Civilization; Vancouver: Douglas and McIntyre, 2006).

28 Jean Blodgett, "The Search for Subject," in Ryan, *Cape Dorset Prints*, 197. For a powerful introduction to Pootoogook's drawings, see Nancy Campbell, *Annie Pootoogook* (Calgary, Alberta: Illingworth Kerr Gallery, Alberta College of Art and Design, 2007).

29 Edwin S. Hall, Jr., Margaret B. Blackman, and Vincent Rickard, *Northwest Coast Indian Graphics: An Introduction to Silk Screen Prints* (Seattle: University of Washington Press, 1981), 50.

30 Hall, Blackman, and Rickard, *Northwest Coast Indian Graphics*, 50.

31 An important recent effort to present and assess the last six decades of Northwest Coast printmaking is the exhibition *Cultural ImPRINT: Northwest Coast Prints*, curated by India Rael Young in collaboration with Faith Brower of the Tacoma Art Museum, in 2017. This follows other projects, including the exhibition *Out of the Frame: Salish Printmaking* at the University of Victoria Legacy Art Gallery in 2016. See the online catalogue of the same title by Andrea N. Walsh and India Rael Young at http://uvac.uvic.ca/gallery/outoftheframe/catalogue (accessed 7-1-17).

32 Personal conversation between George Hunt, Jr. and h. a., November 5, 2014.

33 Vancouver Art Gallery, *Susan Point: Spindle Whorl*, 2017; see www.vanartgallery.bc.ca/the_exhibitions/exhibit_point.html (accessed 3-6-17).

34 Tania Willard, *unlimited edition* (Kamloops, BC, Canada: Kamloops Gallery, 2015). Online publication.

35 Per IAIA website: https://iaia.edu/about/history/ (accessed 8-23-16).

36 Personal conversation between Linda Lomahaftewa and h. a. was instrumental in documenting a complete history of IAIA instructors since her time as a student to current appointments, February 26, 2015.

37 Thanks to Craig Locklear, who confirmed the dates and information for IAIA in a personal conversation with h. a., March 29, 2017.

38 Personal conversation between h. a. and Don Messec, who graciously shared his extensive knowledge of the printmaking community in Santa Fe, March 10, 2015.

39 Personal conversation between Tamarind Director Emerita, Marjorie Devon, and h. a., March 2, 2015.

40 Kathleen Stewart Howe, "A Quiet Commitment: Tamarind and Native American Artists," in Marjorie Devon, ed., *Migrations: New Directions in Native American Art* (Albuquerque, NM: University of New Mexico Press, 2006), 27.

41 See Marjorie Devon, *Tamarind Touchstones: Fabulous at Fifty: Celebrating Excellence in Fine Art Lithography* (Albuquerque, NM: University of New Mexico Press, 2010), 165–176, for a complete list of the artists, including Native artists, who printed at Tamarind from 1960 to 2009.

42 The artists in *Multiple Impressions* included R. C. Gorman (Navajo), T. C. Cannon (Kiowa/Caddo), James Havard (U.S.), Robert Houle (Saulteaux), Phil Hughte (Zuni Pueblo), Felice Lucero-Giaccardo (San Felipe Pueblo), Solomon McCombs (Muscogee Creek), Dan Namingha (Hopi), Duane Slick (Meskwaki/Ho-Chunk), Jaune Quick-to-See Smith (Salish Kootenai/Flathead), Fritz Scholder (Luiseño), Patrick Swazo Hinds (Tesuque Pueblo) and Emmi Whitehorse (Navajo).

43 See Gerald McMaster, "Crow's Shadow: Art and Community," in Devon, ed., *Migrations* (2006), 17–25.

44 Tamarind website, http://tamarind.unm.edu/ (accessed 3-6-17).

45 Deborah Jojola, who received her MFA from the University of New Mexico, where she specialized in printmaking, was awarded a first-place ribbon for printmaking at the Santa Fe Indian Market in 2011. In addition to her long career as a teacher and curator, she maintains a studio, Stone Age Lithography Press, at her home at Isleta Pueblo.

46 This discussion focuses upon Native American printmakers teaching in U.S. college and university fine art programs and does not attempt to survey parallel efforts in Canada or in tribal or First Nations colleges, important subjects worthy of additional research.

47 *Native Perspectives on the Trail: An American Indian Art Portfolio* (Missoula, MT: Missoula Art Museum, 2005). Artists and their tribal affiliations included: Neal Ambrose-Smith (Flathead Salish/Shoshone/Cree), Dwight Billedeaux (Blackfeet), Melissa Bob (Lummi), Damian Charette (Crow/Northern Cheyenne), Corwin Clairmont (Salish Kootenai), Jason Clark (Algonquin), Joe Feddersen (Colville Confederated Tribes), Jeneese Hilton (Blackfeet), Ramon Murillo (Shoshone Bannock), Molly Murphy (Oglala Lakota Sioux, NTA), Neil Parsons (Southern Pikuni), Lillian Pitt (Wasco/Yakama/Warm Springs), Jaune Quick-to-See Smith (Salish Kootenai/Flathead), Gail Tremblay (Onondaga/Mi'kmaq), and Melanie Yazzie (Navajo).

48 This discussion of Allen's career and biography relies on the artist's website: http://www.lynneallen.com/ (accessed 8-12-16). Allen's work, along with that of eleven other artists, is featured in *New Impressions: Experiments in Contemporary Native American Printmaking*, an exhibition organized in 2015 by the International Print Center New York. See the accompanying essay, "Weaving Past into Present: Experiments in Contemporary Native American Printmaking," by exhibition coordinator Sarah Diver: www.ipcny.org/sandbox/wp-content/uploads/2015/06/WeavingPastintoPresent_Essay.pdf (accessed 6-27-17).

49 See Rebecca J. Dobkins, *Joe Feddersen: Vital Signs* (Salem, OR: Hallie Ford Museum of Art, 2008), for an exploration of Feddersen's work and career. Recently, in 2013–14, with the support of the Longhouse Education and Cultural Center at The Evergreen State College, Feddersen organized a groundbreaking print portfolio, *Terrain: Plateau Art and Poetry*, that included the work of thirty-four Plateau artists and writers, addressing the emotional and physical landscape of their homeland.

50 See Jo Ortel, "John Hitchcock's Ground Zero," in *Epicenter: John Hitchcock* (Madison, WI: University of Wisconsin and Wisconsin Alumni Research Foundation, 2011) and at *Epicenter*, http://www.hybridpress.net/publications (accessed 6-27-17), n.p.

51 See artist statement associated with *What's Your Sugar?* series: https://www.doi.gov/iacb/marwin-begaye-whats-your-sugar (accessed 3-19-17).

52 Mary Hood, "Map*(ing)*: Multiple Artists Printing (Indigenous and Native Geographies)," *American Indian Art Magazine* 36(4) (2013): 54–59.

53 Many scholars and curators, in addition to those cited so far in this essay, have championed the work of Indigenous printmakers. Among them, Nancy Marie Mithlo has been instrumental in curating the work of Indigenous printmakers and other artists and securing international venues, especially at the Venice Biennale, since 1999. Suzanne Newman Fricke has also celebrated Indigenous printmaking and photography in her curatorial work. See the exhibition catalogue with essays by both Mithlo and Fricke: *Air, Land, Seed* and *Octopus Dreams* (Albuquerque, NM: 516 Arts, 2013), and http://516arts.org/images/stories/PDFs/2013/summer2013_catalog_web.pdf (accessed 6-26-17).

54 The authors recognize the list of artists referenced in this essay is incomplete and wish to acknowledge that there are other significant U.S. and Canadian Indigenous artists and instructors whose printmaking merits further discussion, including Jason Garcia, Bobby Martin, Dylan Miner, Marvin Oliver, Alex Peña, and Tony Tiger. To all these artists, the authors pledge to keep working as hard you do to document this medium and its related movements.

This book and the associated exhibition celebrate the first twenty-five years of Crow's Shadow Institute of the Arts. In the plates that follow, we present selected work from every artist in residence from 2001 to 2016, organized alphabetically by artist. While many artists from youths to elders have visited CSIA since its opening in 1992, this book focuses upon the work of fifty artists who have held official printmaking residencies since 2001 and who have published with Crow's Shadow Press in collaboration with printer-in-residence Frank Janzen, a Tamarind Master Printer.

Each artist is represented by at least one print; for artists who have been in residence more than once, a print from each year of residency is included. Prints may be either from editions of lithographs, etchings, linocuts or woodcuts, or series of monoprints or monotypes. In the caption for each image, the year of publication is followed by the process employed in printing, a description of the type of paper used in printing, the dimensions of the paper, and the Crow's Shadow Press (CSP) number (e.g., CSP 01-102). The print documentation numbers follow a system similar to that of the Tamarind Institute, developed by Frank Janzen especially for CSIA. CSP refers to Crow's Shadow Press; the first two digits indicate the year the print was started, and the next three digits refer to the type of print made. If the print is from a series of monoprints or monotypes, the CSP number is followed by a bracketed number, to indicate which impression it is from the series. Each print is embossed with the CSP chop (the press's mark) on the lower left, and the individual printer's chop (in all cases, Frank Janzen's) on the lower right. Following Tamarind Institute standards, Janzen's meticulous documentation for every print records the methods and matrixes used in printing, the color trial proofs, and the impressions made. CSP print documentation is archived at the Crow's Shadow Institute of the Arts Archives, Hallie Ford Museum of Art, as well as at CSIA.

Following the conventions of art editors, we identify artists by nationality and/or country of birth. Indigenous artists are identified by their tribal nationalities, and other artists by their nation-state and, if different, their country of birth. A glossary of relevant printmaking terms follows the plates.

While we chose to organize the plates by the most straightforward organizing principle we could devise (alphabetically by artist), the accompanying exhibition, which includes additional prints, is organized thematically, allowing for the exploration of how artists who have printed at CSIA have experimented with abstraction, landscape, media and process, portraiture, and word and image.

REBECCA J. DOBKINS
Curator of Native American Art
Hallie Ford Museum of Art

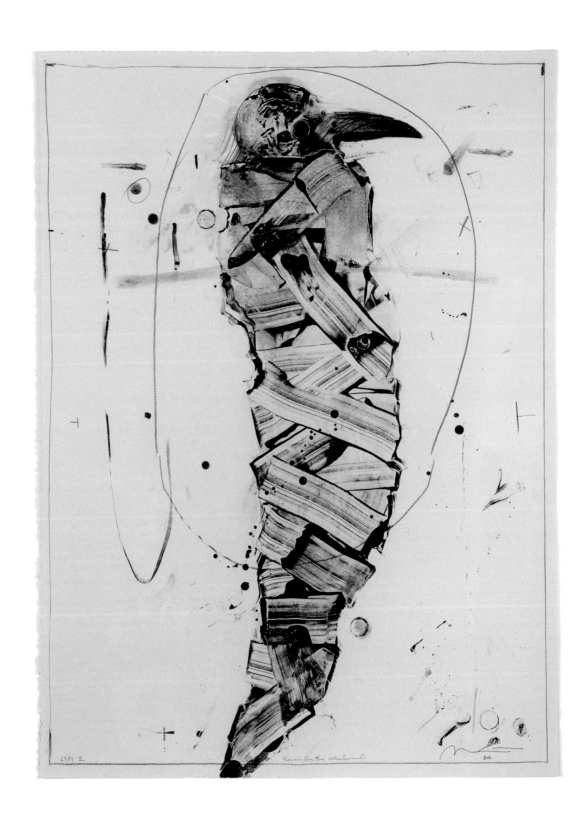

RICK BARTOW

(Wiyot, 1946–2016)

Raven in the Whirlwind, 2004, series of 10, monoprint on Rives BFK
cream paper, 30 x 22¼ in., CSP 04-307.

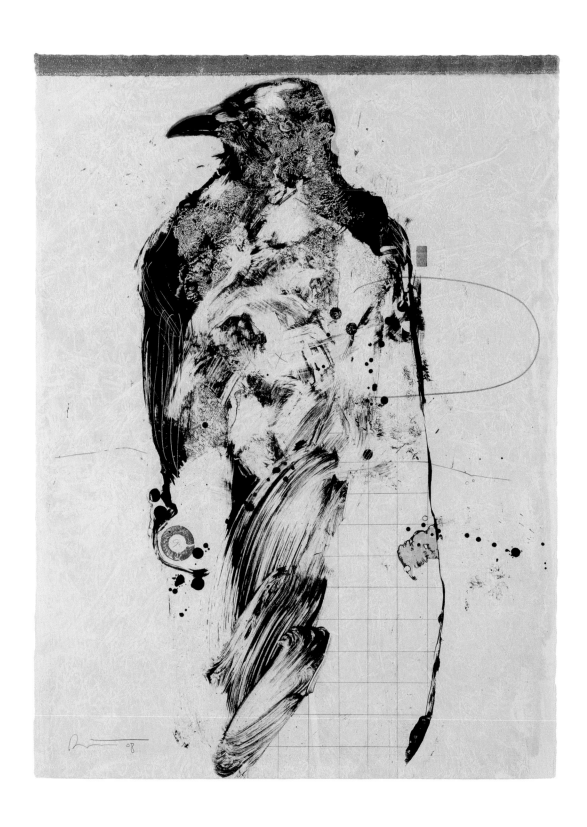

Facing Left Raven, 2008, series of 16, monoprint on Rives BFK white
paper, 30 x 22 ³/₈ in., CSP 08-303(9).

RICK BARTOW (Wiyot, 1946–2016), *Crow Shadow*, 2013, series of 20,
monoprint on Rives BFK white paper, 30 1/8 x 22 1/2 in., CSP 13-302(9).

Crow in a Boat, 2013, series of 22, monoprint on Rives BFK white
paper, 30 1/8 x 22 1/2 in., CSP 13-304(8).

GABRIELLE BELZ

(Māori, Ngā Puhi, Te Ātiawa, b. 1947)

Pou Series V, 2011, series of 8, monotype on Rives BFK white paper,
14 ¼ x 7 ¹¹/₁₆ in., CSP 11-309(5).

PAT BOAS

(U.S., b. 1952)

Unalphabetic #1 (unabashed), 2012, ed. 12, six-color lithograph on
Arches 88 white paper, 30 x 22½ in., CSP 12-117.

JOE CANTRELL

(Cherokee, b. 1945)

Coyote's Time Scales, 2016, ed. 15, four-color lithograph on Somerset Satin white paper and Rives BFK white paper, 26½ x 33 ⅕ in., CSP 16-115.

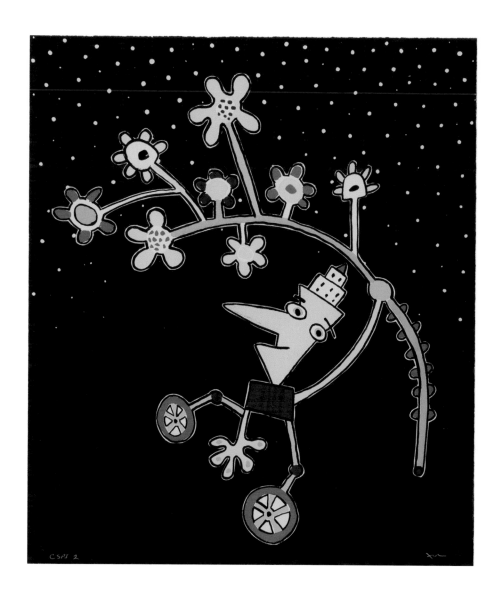

ADNAN CHARARA

(U.S., born Sierra Leone, 1962)

Falling in Love, 2009, ed. 25, eight-color lithograph on Rives BFK white
paper, 23 x 20 in., CSP 09-102.

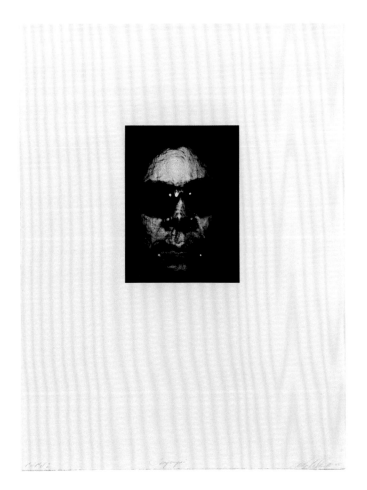

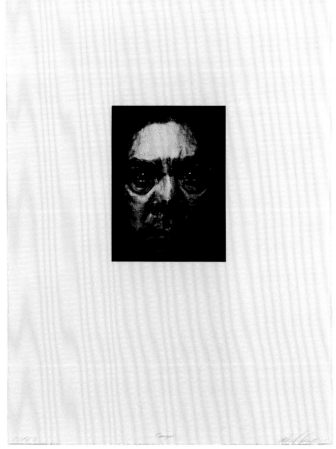

PHILLIP JOHN CHARETTE

(Yup'ik, b. 1962)

Tangvagai ("He is watching them"), from *Angalkuq: Shaman or Medicine Man*, 2005, ed. 16, two-color lithograph on Somerset Satin white paper and Rives BFK white paper, 30 x 22 ³/₈ in., CSP 05-112 a.

Caugai ("He is confronting them"), from *Angalkuq: Shaman or Medicine Man*, 2005, ed. 16, two-color lithograph on Somerset Satin white paper and Rives BFK white paper, 30 x 22 ³/₈ in., CSP 05-112 b.

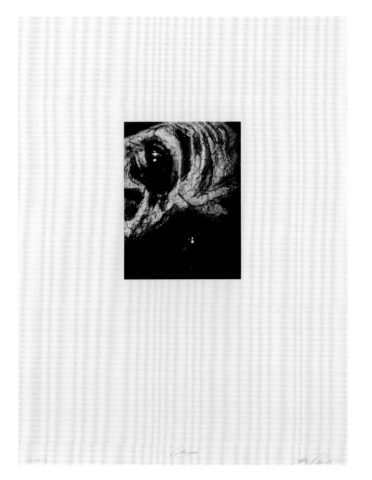

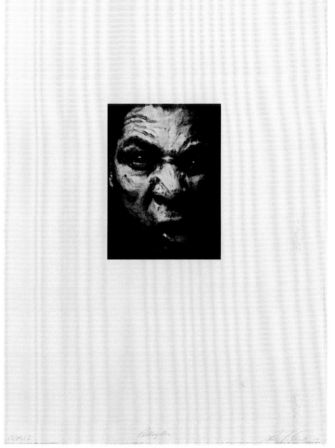

Callugai ("He is fighting them"), from *Angalkuq: Shaman or Medicine Man*, 2005, ed. 16, two-color lithograph on Somerset Satin white paper and Rives BFK white paper, 30 x 22 ³/₈ in., CSP 05-112 c.

Pellugtaa ("He brought them through"), from *Angalkuq: Shaman or Medicine Man*, 2005, ed. 16, two-color lithograph on Somerset Satin white paper and Rives BFK white paper, 30 x 22 ³/₈ in., CSP 05-112 d.

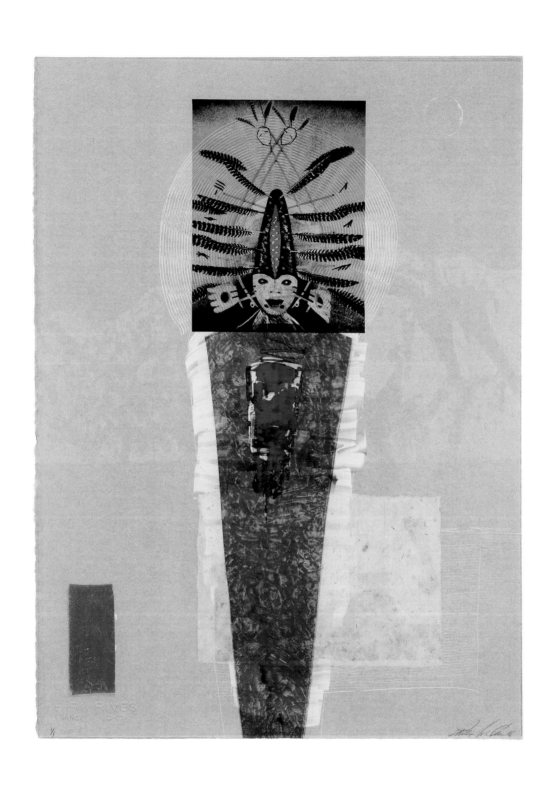

PHILLIP JOHN CHARETTE *Medicine*, 2008, series of 14, monotype
on Rives BFK white paper, various handmade papers, and acid-free
transfer film, 30¼ x 22¼ in., CSP 08-302(8).

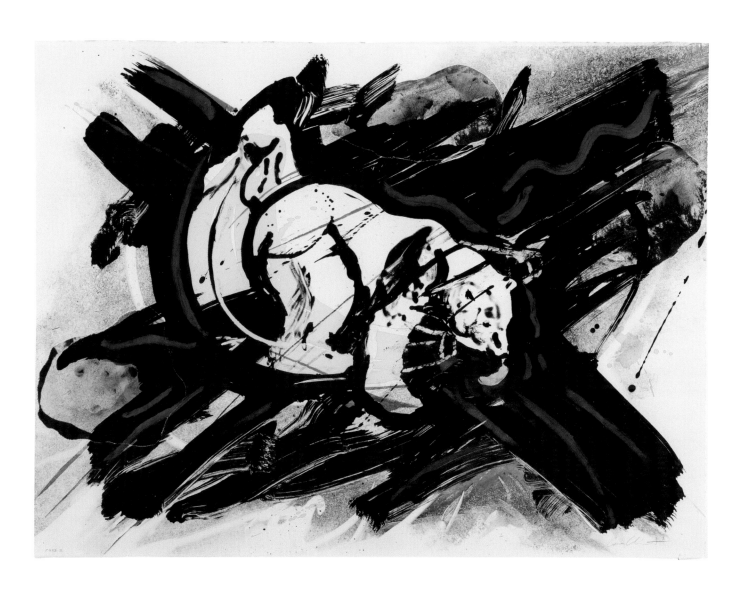

CORWIN CLAIRMONT

(Salish Kootenai, b. 1946)

Banana Polar Bear, 2012, series of 15, monoprint on Somerset Satin
white paper, 22 3/8 x 30 in., CSP 12-301(5).

JIM DENOMIE

(Ojibwe, b. 1955)

Untruthful, 2011, series of 8, monoprint on Rives BFK white paper,
30 x 22 3/8 in., CSP 11-305(6).

Canoe, 2011, series of 12, monoprint with oil pastel handwork on
Rives BFK white paper, 30 x 22 ³/₈ in., CSP 11-308(4).

DANIEL DUFORD

(U.S., b. 1968)

Dam Breach, 2015, series of 13, monoprint on Somerset Satin white
paper, 22 x 30 in., CSP 15-303(7).

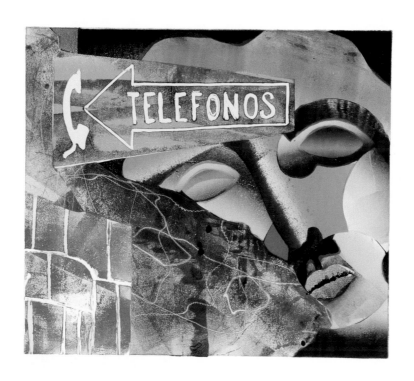

VANESSA ENOS

(Walla Walla/Yakama/Pima, enrolled Northern Cheyenne, b. 1981)

Memory LN, 2009, series of 9, monotype on Rives BFK white paper,
handprinted by artist, 22 3/8 x 18 1/2 in., CSP 09-319(2).

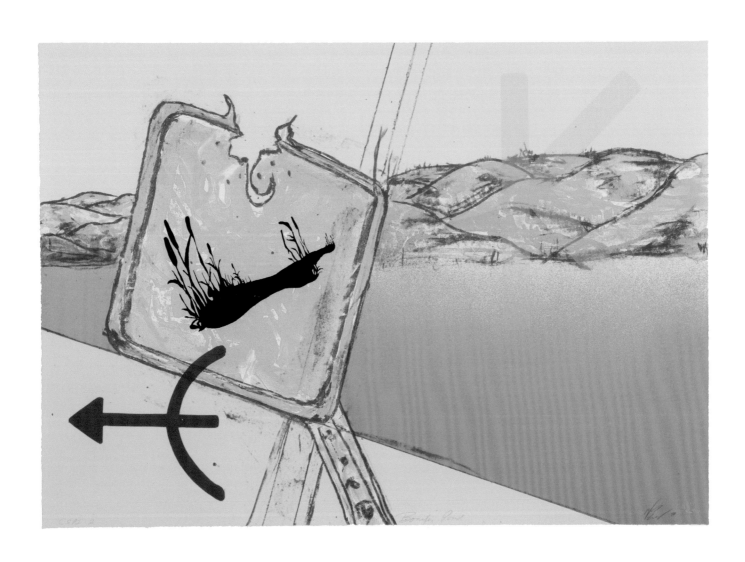

VANESSA ENOS (Walla Walla/Yakama/Pima, enrolled Northern
Cheyenne, b. 1981), *Bonifer Pond*, 2009, ed. 16, eight-color lithograph
on Somerset Satin white paper, 17 x 24 in., CSP 09-108.

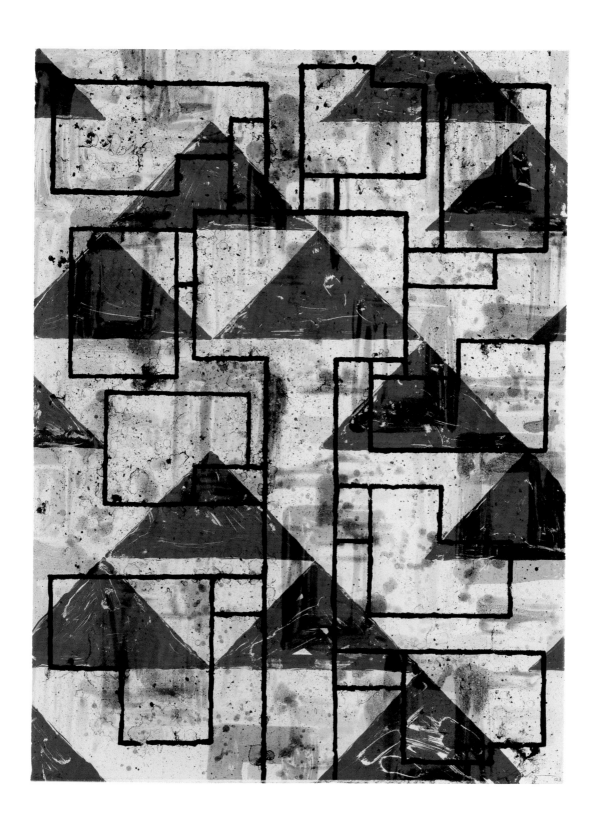

JOE FEDDERSEN

(Colville Confederated Tribes, b. 1953)

Wyit View, 2003, ed. 16, six-color lithograph on Rives BFK white paper,
40 x 30 in., CSP 03-105.

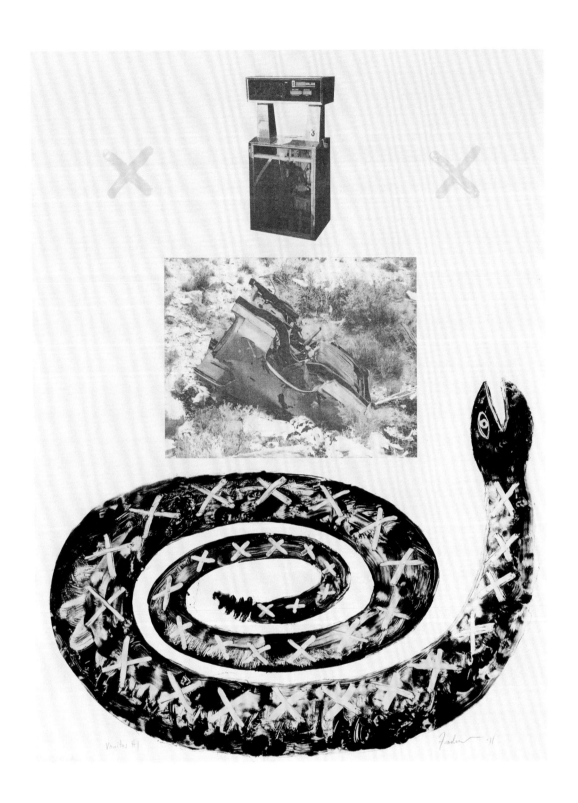

JOHN FEODOROV

(Navajo, b. 1960)

Vanitas #1, 2011, ed. 12, four-color lithograph on Rives BFK white
paper, 30 x 22¼ in., CSP 11-101.

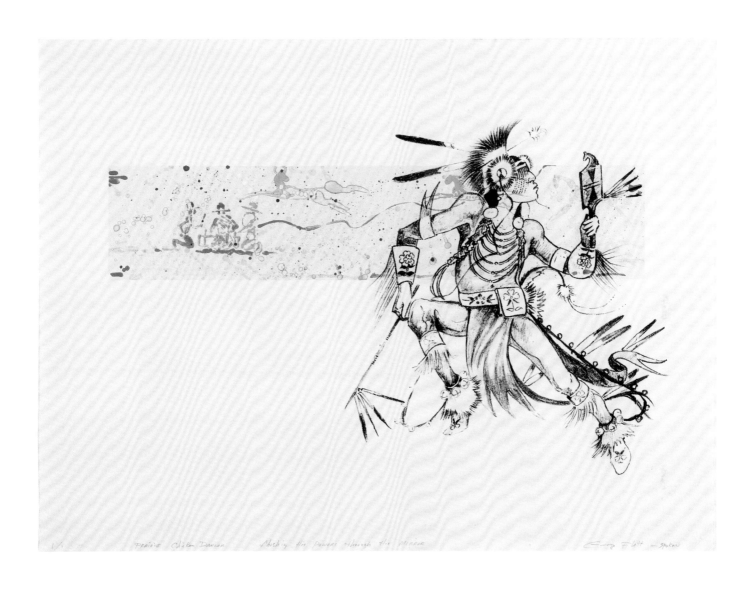

GEORGE FLETT

(Spokane, 1947–2013)

Prairie Chicken Dancer Flashing His Power through His Mirror, 2007,
series of 21, monoprint on Somerset Satin white paper, 22 3/8 x 30 in.,
CSP 07-301(6).

RIC GENDRON

(Colville Confederated Tribes, b. 1954)

Rattle, 2010, series of 12, monoprint on Rives BFK white paper,
30 x 22¼ in., CSP 10-303(6).

Raven Heart, 2010, series of 12, monoprint on Rives BFK white paper,
30 x 22¼ in., CSP 10·306(3).

JEFFREY GIBSON

(Mississippi Band of Choctaw/Cherokee, b. 1972)

One for the Other, 2008, ed. 20, six-color lithograph on Rives BFK white
paper, 19½ x 15½ in., CSP 08-101.

DAMIEN GILLEY

(U.S., b. 1977)

Everything Incorporated, 2013, ed. 12, four-color lithograph on
Somerset Satin white paper, 22 x 30 in., CSP 13-111.

DON GRAY

(U.S., b. 1948)

The Life of Stones, 2009, series of 11, monotype printed on Somerset
Satin white paper, 22¼ x 23½ in., CSP 09-315(4).

EDGAR HEAP OF BIRDS

(Cheyenne, b. 1954)

Neuf for Modoc, 2001, ed. 30, eighteen-color lithograph on Rives BFK
white paper, 22½ x 30 in., CSP 01-102.

WUON-GEAN HO

(U.K., b. 1973)

Guardian IV, 2005, ed. 20, two-color lithograph on Rives BFK white paper, 21 x 15 in., CSP 05-109.

ARNOLD KEMP

(U.S., b. 1968)

Mirror Fragments, 2012, ed. 12, four-color lithograph on Somerset
Satin white paper, 30 x 22 ⅛ in., CSP 12-109.

EVA LAKE

(U.S., b. 1956)

Sky Over Casino, 2011, ed. 14, eight-color lithograph on Somerset
Satin white paper, 30 x 30 in., CSP 11-113.

FRANK LAPENA

(Wintu, b. 1937)

Gatekeepers of the Invisible, 2012, ed. 12, six-color lithograph on
Somerset Satin white paper, 16 15/16 x 16 15/16 in., CSP 12-102.

JAMES LAVADOUR

(Walla Walla, b. 1951)

Ghost Camp, 2002, ed. 16, suite of four, four-color lithographs with
graphite pencil on Arches 88 white paper, 17 x 21 ¾ in. each,
34 ¼ x 43 ¾ in. overall, CSP 02-114 a, b, c, d.

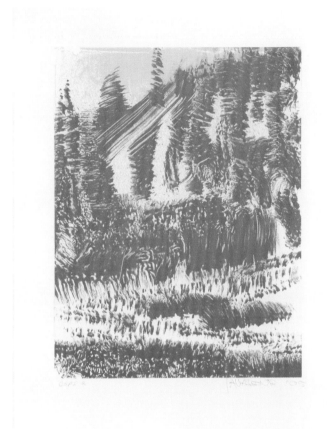

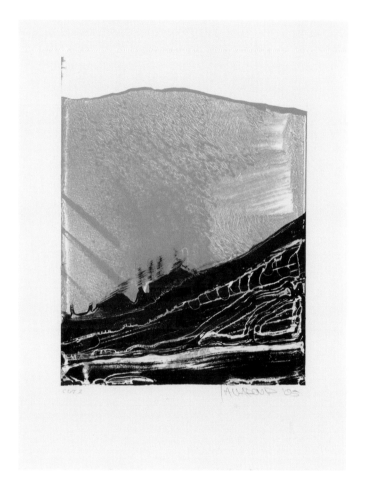

Untitled, Early Spring in February 2005, 2004, ed. 50, lithograph on Rives BFK white paper, 15 x 11¼ in., CSP 04-101.

Untitled, Early Spring in February 2005, 2004, ed. 50, two-color lithograph on Rives BFK white paper, 15 x 11¼ in., CSP 04-102.

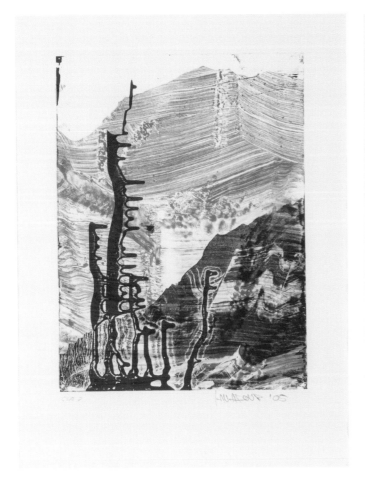

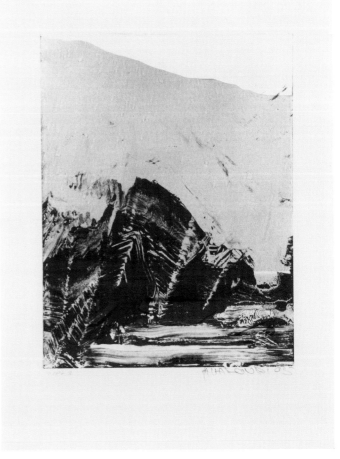

JAMES LAVADOUR (Walla Walla, b. 1951), *Untitled, Early Spring in February 2005*, 2004, ed. 50, two-color lithograph on Rives BFK white paper, 15 x 11¼ in., CSP 04-103.

Untitled, Early Spring in February 2005, 2004, ed. 50, two-color lithograph on Rives BFK white paper, 15 x 11¼ in., CSP 04-104.

Untitled, Early Spring in February 2005, 2004, ed. 50, two-color lithograph on Rives BFK white paper, 15 x 11¼ in., CSP 04-105.

Untitled, Early Spring in February 2005, 2004, ed. 50, two-color lithograph on Rives BFK white paper, 15 x 11¼ in., CSP 04-106.

JAMES LAVADOUR (Walla Walla, b. 1951), *Untitled, Early Spring in February 2005*, 2004, ed. 50, two-color lithograph on Rives BFK white paper, 15 x 11¼ in., CSP 04-107.

Untitled, Early Spring in February 2005, 2004, ed. 50, two-color lithograph on Rives BFK white paper, 15 x 11¼ in., CSP 04-108.

Land of Origin, 2015, ed. 18, suite of four, three-color lithographs on Arches 88 white paper, 22½ x 30¼ in. each, 45 x 60½ in. overall, CSP 15-101 a, b, c, d.

TRUMAN LOWE

(Ho-Chunk, b. 1944)

Wána náxš, 2002, ed. 12, four-color lithograph on Kanzesui paper and
Arches 88 paper, 30 x 22½ in., CSP 02-106.

JAMES LUNA

(Luiseño, b. 1950)

Sumojazz, 2011, series of 16, monotype on Rives BFK white paper
with Kitakata, Owarra mulberry, silk tissue, and Kozo lightweight
papers, 30 x 22½ in., CSP 11-301(14).

JAMES LUNA *Indian Edge*, 2011, series of 16, monotype on Rives
BFK white paper with Kitakata and Rives heavyweight papers,
22¼ x 26 in., CSP 11-302(16).

VICTOR MALDONADO

(U.S., b. Mexico [Purepecha]), 1976)

Lucha, 2014, series of 33, monotype on Arches 88 white paper,
triptych, 22 ½ x 22 ½ each, 22 ½ x 67 ½ in. overall, CSP 14-301
(9, 11, 4).

BRENDA MALLORY

(Cherokee, b. 1944)

Crossings, 2016, ed. 14, one-color lithograph on Rives BFK white
paper, 40 x 29¾ in., CSP 16-101.

The Plural of Nexus, 2016, ed. 14, one-color lithograph on Rives BFK
white paper, 30 x 22 ³/₈ in., CSP 16-102.

LARRY MCNEIL

(Tlingit/Nisga'a, b. 1955)

Native Epistemology, 2004, ed. 25, five-color lithograph on Rives BFK
white paper, 30 x 22¼ in., CSP 04-205.

Edward Curtis' Last Photograph, 2004, ed. 25, five-color lithograph on
Rives BFK white paper, 30 x 22¼ in., CSP 04-206.

LARRY MCNEIL (Tlingit/Nisga'a, b. 1955), *Diacritical Formline, Chilkat Style*, 2007, ed. 20, four-color lithograph on Rives BFK white paper, 30 x 22½ in., CSP 07-101.

Bonehead Humans, 2007, ed. 20, four-color lithograph on Rives BFK
white paper, 22 x 15½ in., CSP 07-102.

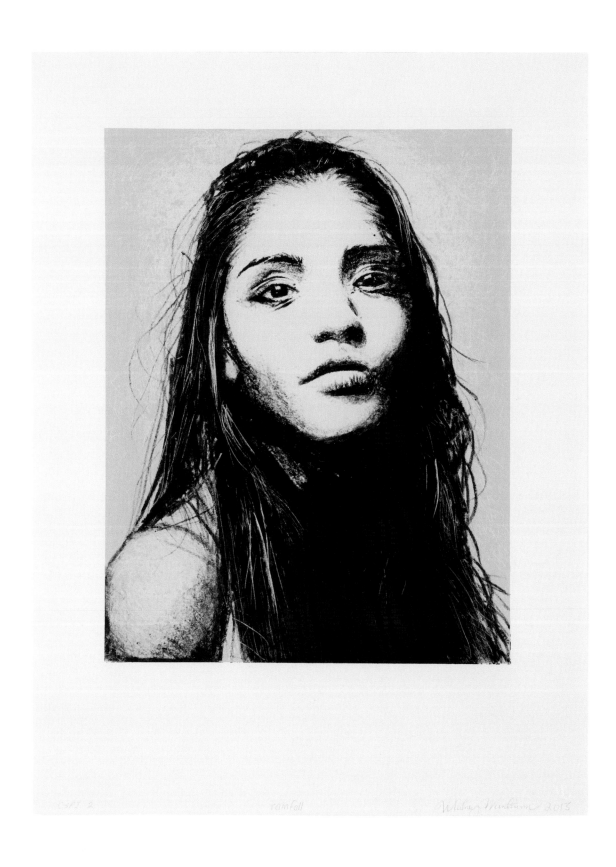

WHITNEY MINTHORN

(Umatilla, b. 1990)

rainfall, 2013, ed. 16, two-color lithograph on Rives BFK white paper,
20 x 15 in., CSP 13-102.

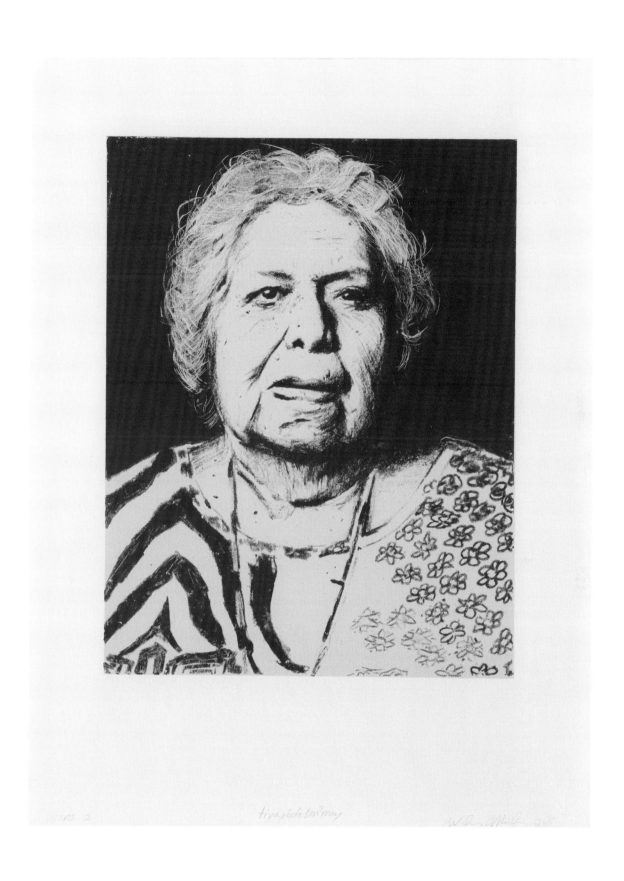

tiyapoolasan'may – the sound the wind makes in the treetops, 2013,
ed. 16, two-color lithograph on Rives BFK white paper, 20 x 15 in.,
CSP 13-104.

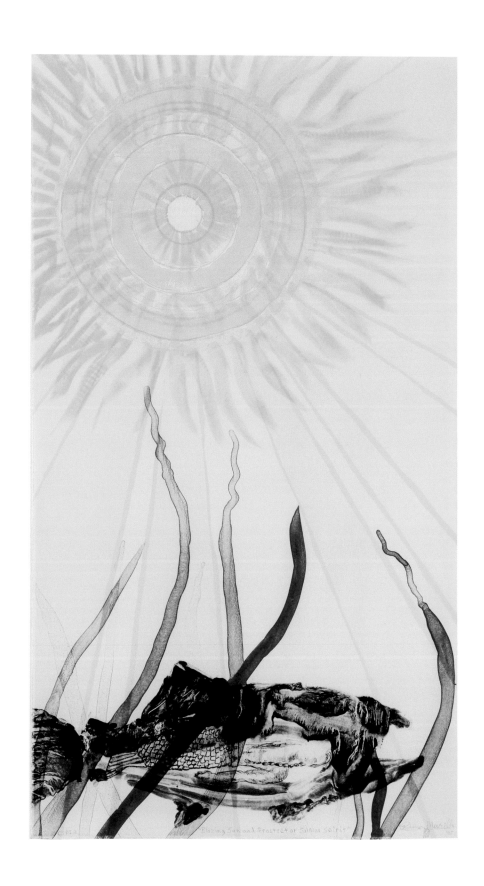

RAMON MURILLO

(Shoshone-Bannock, b. 1956)

Blazing Sun and Protector Salmon Spirit, 2005, ed. 10, eight-color
lithograph on Rives BFK white paper, 32 x 18 in., CSP 05-101.

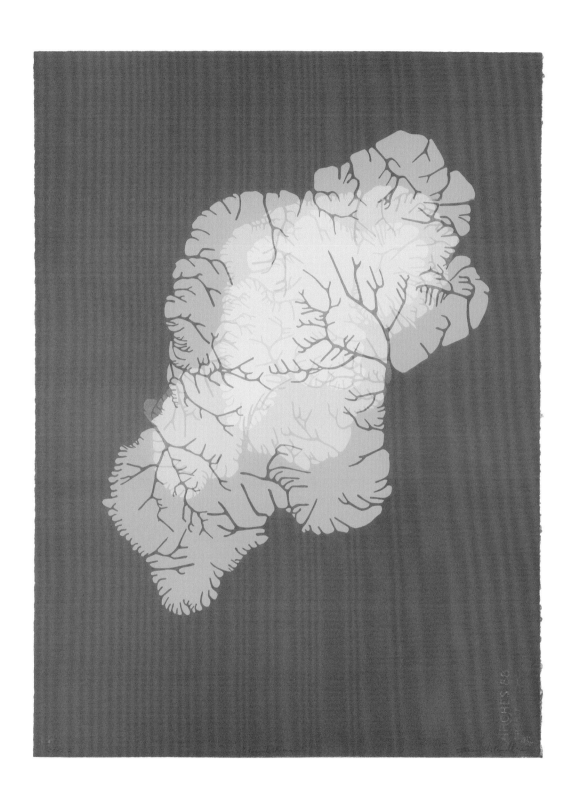

SUSAN MURRELL

(U.S., b. 1973)

tunnel through, 2012, ed. 12, four-color lithograph on Arches 88 white
paper, 22 ¾ x 22 ¾ in., CSP 12-107.

JENENE NAGY

(U.S., b. 1975)

blackout (silver), 2011, ed. 14, three-color lithograph on Arches 88
white paper, diptych, 22 ¾ x 23 in. each, 22 ¾ x 46 in. overall
(with ½ in. space between prints), CSP 11-119 a, b.

RYAN PIERCE

(U.S., b. 1979)

Sentinel, 2016, ed. 18, six-color lithograph on Somerset Satin white paper, 30 x 22¼ in., CSP 16-110.

LILLIAN PITT

(Wasco/Yakama/Warm Springs, b. 1943)

Round Dance, 2006, ed. 20, two-color lithograph on Rives BFK white
paper, 15 x 20 in., CSP 06-105.

Pipestone Secrets, 2013, ed. 10, four-color lithograph on Kitikata
paper, 16 ¾ x 19 in., CSP 13-113.

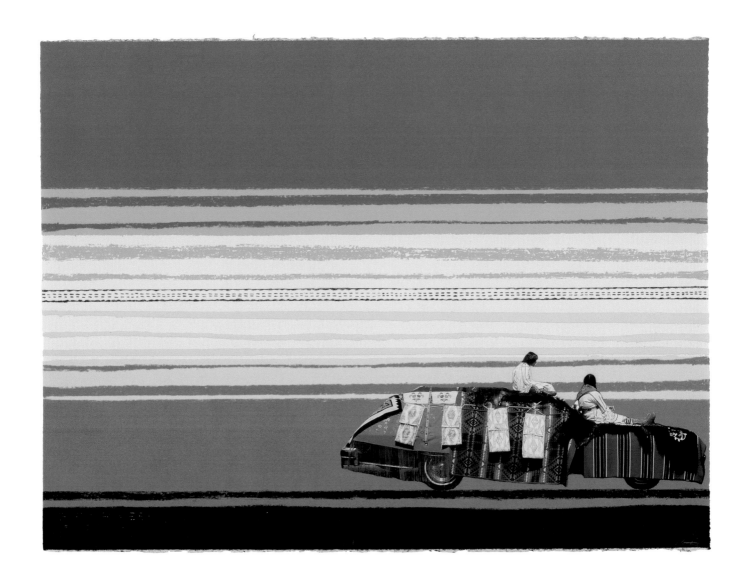

WENDY RED STAR

(Apsáalooke, b. 1981)

enit, 2010, ed. 12, six-color lithograph on Rives BFK white paper with
chine collé archival pigment ink photograph on Moab Entrada paper,
22 3/8 x 30 in., CSP 10-101.

The (HUD), 2010, ed. 12, two-color lithograph on Rives BFK white paper with chine collé archival pigment ink photographs on Moab Entrada paper, 30 x 22 3/8 in., CSP 10-102.

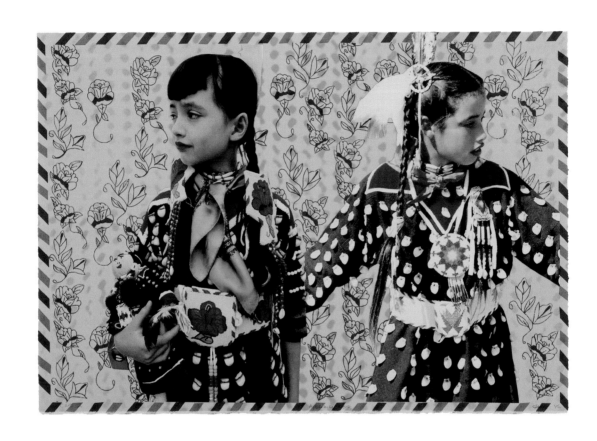

WENDY RED STAR (Apsáalooke, b. 1981), *Apsáalooke Roses*, 2015, ed.
12, four-color lithograph on Somerset Satin white paper with chine
collé archival pigment ink photographs on Moab Entrada paper,
18 x 26 in., CSP 15-103.

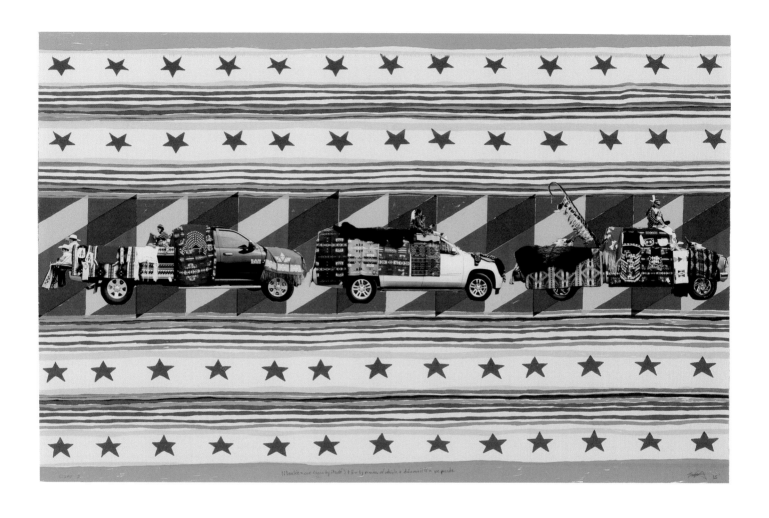

iilaalée = car (goes by itself) + ii = by means of which + dáanniili = we parade, 2015, ed. 20, nine-color lithograph on Somerset Satin white paper with chine collé archival pigment ink photographs on Moab Entrada paper, 24 x 38 in., CSP 15-104.

MICHELLE ROSS

(U.S., b. 1962)

Transaction 12 (Oh Arturo – A), 2015, series of 23, monotype on Rives
BFK white paper and archival pigment ink photograph on Moab
Entrada paper, 17 x 17 in., CSP 15-305(12).

BLAIR SAXON–HILL

(U.S., b. 1979)

The advantage of sunset, 2013, ed. 10, three-color lithograph on Rives
BFK white paper, 30 ⅛ x 22 ⅛ in., CSP 13-105.

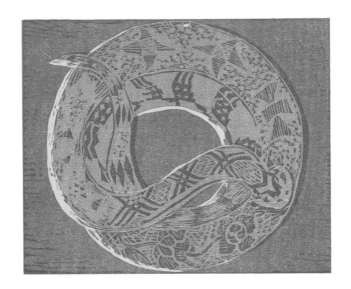

SUSAN SHEOSHIPS

(Cayuse/Walla Walla, b. 1951)

Untitled, 2008, ed. 16, three-color woodcut on Rives BFK white paper,
17½ x 17 in., CSP 08-602.

SARA SIESTREEM

(Hanis Coos, b. 1976)

GOOD LUCK, LOVE, AND MONEY, 2013, ed. 16, two-color lithograph
on reverse of Rives BFK white paper, 40 x 30 in., CSP 13-106.

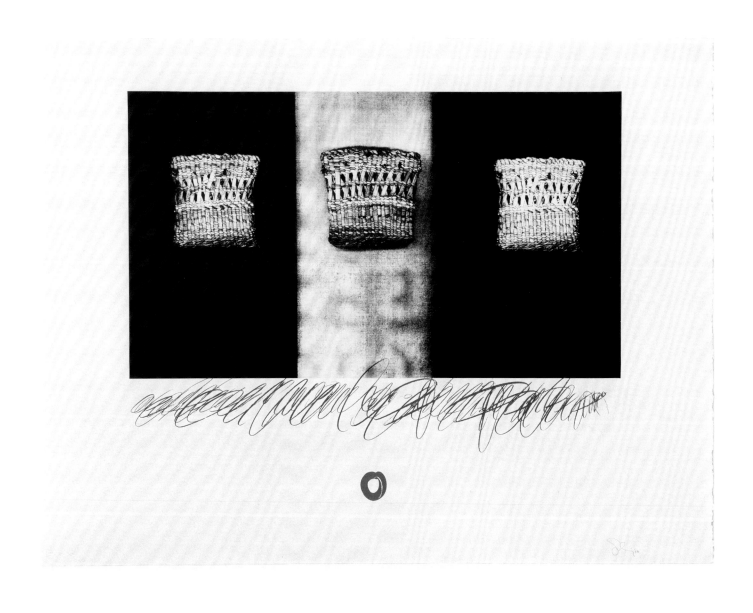

SARA SIESTREEM (Hanis Coos, b. 1976), *FIRST BASKET*, 2013, ed. 16,
three-color lithograph on reverse of Rives BFK paper, 30 1/8 x 40 in.,
CSP 13-107.

124

RYAN LEE SMITH

(Cherokee/Choctaw, b. 1972)

Bare Foot, 2004, ed. 25, four-color lithograph on Rives BFK white
paper, 22 ¼ x 30 in., CSP 04-208.

ADAM SORENSEN

(U.S., b. 1976)

Atoll I, 2014, ed. 14, eight-color lithograph on Rives BFK white paper,
22 3/8 x 30 in., CSP 14-103.

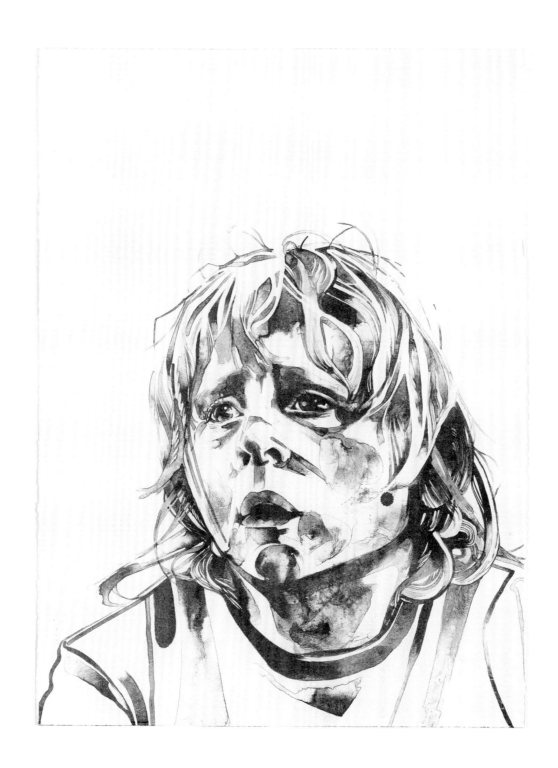

STORM THARP

(U.S., b. 1970)

Young People 2, 2011, ed. 12, one-color lithograph on Rives BFK white
paper, 30 x 22 ³/₈ in., CSP 11-107.

MARTY VREEDE

(New Zealand, b. 1955)

Kahu – Birth of a Messenger, 2009, ed. 32, three-color lithograph on
Somerset Satin white paper, 9½ x 22⅜ in., CSP 09-106.

KAY WALKINGSTICK

(Cherokee, b. 1935)

Bitterroot Winter, 2003, ed. 16, two-color linocut/lithograph on Rives
BFK white paper, 17¼ x 30 in., CSP 03-601.

KAY WALKINGSTICK (Cherokee, b. 1935), *Bearpaw Battlefield 1*, 2003,
ed. 16, two-color etching/lithograph on Rives BFK white paper, 17 x
30 in., CSP 03-701.

SAMANTHA WALL

(U.S., b. South Korea, 1977)

Dark Matter (Universal Body 1), 2016, ed. 20, two-color lithograph
(silver over black) on Arches 88 white paper, 30 x 22¾ in.,
CSP 16-105.

MARIE WATT

(Seneca, b. 1967)

Sanctuary, 2002, ed. 12, two-color lithograph on Rives BFK grey paper,
17½ x 18½ in., CSP 02-112.

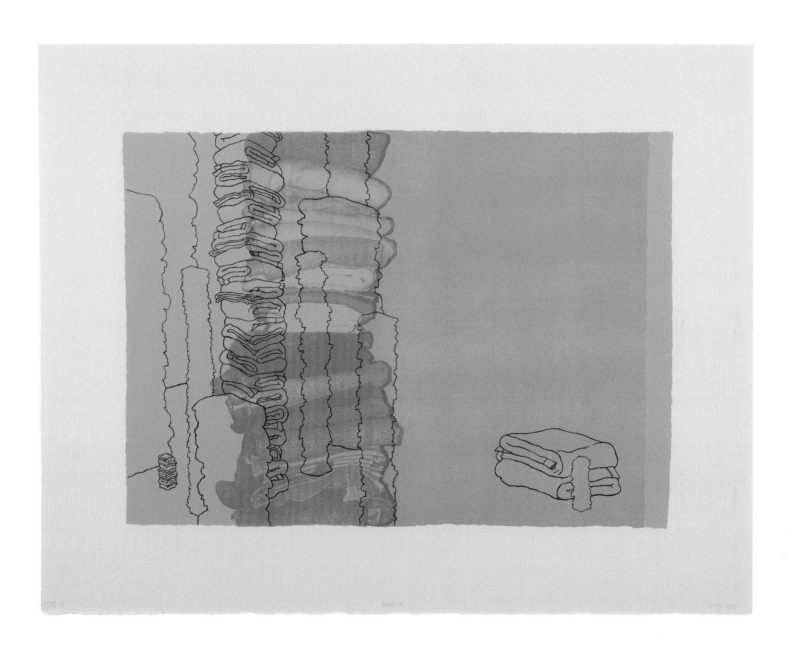

Blankets, 2003, ed. 16, five-color lithograph on Rives BFK grey paper,
19 ¾ x 25 ¾ in., CSP 03-108.

MARIE WATT (Seneca, b. 1967), *Lodge*, 2005, ed. 20, two-color
woodcut on Somerset Satin white paper, 16½ x 14 in., CSP 05-601.

Camp, 2011, ed. 20, two-color woodcut on Somerset Satin white
paper, 20¾ x 16 in., CSP 11-604.

JEREMY RED STAR WOLF

(Umatilla/Cayuse/Walla Walla, b. 1977)

It's Good to be Alive, 2006, ed. 12, one-color lithograph on Kitakata
paper and Rives BFK white paper, 25 x 15 in., CSP 06-106.

MELANIE YAZZIE

(Navajo, b. 1966)

Yazzie Girl in Pendleton, 2012, ed. 16, three-color woodcut/lithograph
on Rives BFK white paper, 39¼ x 30⅛ in., CSP 12-601.

SHIROD YOUNKER

(Coquille/Miluk Coos, b. 1972)

kahss K'wahyayis, 2014, ed. 12, two-color lithograph with archival
pigment ink photograph on Rives BFK white paper, 30 x 22¼ in.,
CSP 14-102.

ZHANG YUNLING

(Naxi [Chinese], b. 1955)

Ancient Naxi Landscape: Ploughing with Deer, 2003, ed. 20, five-color
lithograph on Kitakata paper, 10 3/8 x 16 7/8 in., CSP 03-103.

NEZ PERCE ARTIST RESIDENCY, CROW'S SHADOW INSTITUTE OF THE ARTS, 2007

In 2007, six Nez Perce artists, sponsored by the Nez Perce Arts Council, participated in a four-day residency at Crow's Shadow as part of a larger tribal arts initiative, "Old Symbols – New Visions," which challenged artists to attempt a new contemporary art medium. Each artist, in collaboration with master printer Frank Janzen, produced two linocuts, one of which is included here.

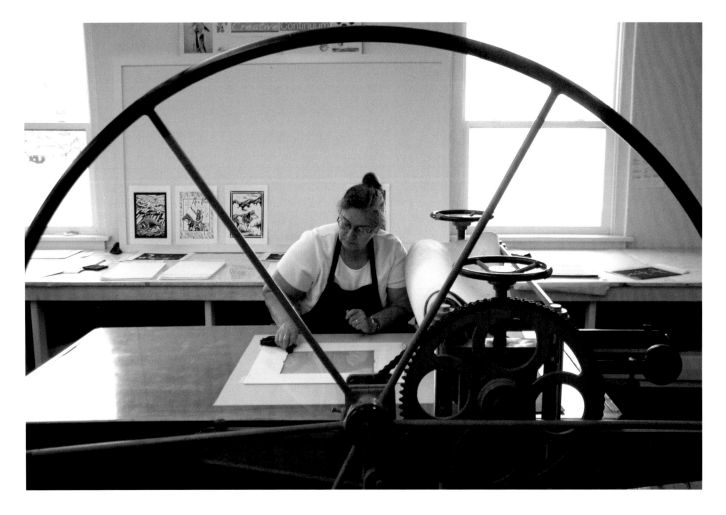

Artist Agnes Weaskus (Nez Perce) at Crow's Shadow. Photo: Walters Photographers.

ELSIE CREE (Nez Perce, b. 1991), *Untitled*, 2007, linocut on Rives BFK
white paper, 15 x 11¼ in., CSP 07·602. Photo: Frank Miller.

FLORENE DAVIS (Nez Perce, b. 1932), *Revolution*, 2007, linocut on Rives
BFK white paper, 11 ¼ x 15 in., CSP 07-604. Photo: Frank Miller.

HELEN GOODTEACHER (Nez Perce, b. 1977), *Sustaining the Salmon*, 2007,
linocut on Rives BFK white paper, 11¼ x 15 in., CSP 07·609.
Photo: Frank Miller.

MARY MARGARET MCCORMACK (Nez Perce, b. 1967), *The Tree of Life*, 2007,
linocut on Rives BFK white paper, 15 x 11 ¼ in., CSP 07-606.
Photo: Frank Miller.

AGNES WEASKUS (Nez Perce, b. 1948), *Beyond Extinction*, 2007,
linocut on Rives BFK white paper, 11¼ x 15 in., CSP 07-607.
Photo: Frank Miller.

JOHN SEVEN WILSON (Nez Perce, b. 1966), *Naco'ox*, 2007, linocut on
Rives BFK white paper, 15 x 11¼ in., CSP 07-612. Photo: Frank Miller.

GLOSSARY OF PRINTMAKING TERMS

CHINE COLLÉ A process that involves gluing thin paper to heavier printmaking paper and then putting both through a press. The pressure causes them to adhere to each other, and the image can be seen through the delicate paper overlay. The term, which refers to the source of the paper originally used in the process, is translated from French as "Chinese glue."

CHOP A stamp embossed on a print to identify the print studio and/or the printer. An artist signs the print to verify his/her involvement in the process; the printer "signs" the print with a chop mark.

COLLAGE The process of creating an artwork by gluing different materials onto a surface. Collage may be used in combination with printmaking processes.

DRYPOINT This process begins with the artist scratching a drawing into a metal plate using a drypoint or sharp tool such as a scribe. The plate is then inked and printed in relief or intaglio. If printed in intaglio, drypoint is recognizable by a characteristic velvety blurry line.

EDITION A set of essentially identical prints made from the same matrix. Each print in a limited edition is customarily numbered, in the lower left-hand margin of the print, with its number within the edition shown over the size of the edition (12/25). A limited edition is one in which no more prints can be made from the matrix, as the printer has "struck" the plate with an *X* after the last number was produced. An impression is a numbered print from an edition.

ETCHING In this process, the artist uses a metal plate coated with a waxy substance, or ground, and draws through the ground with a stylus to expose the metal plate. The plate is immersed in an acid bath, "biting" the lines into the plate, which is then inked and printed.

INTAGLIO A term for printmaking techniques that transfer ink from the recesses of a matrix rather than its surfaces. Ink is rubbed into the plate and then wiped off, leaving ink in the crevasses. When printed with pressure, the dampened paper pulls the ink from the recesses. The term comes from the Italian verb *intagliare*, "to engrave."

LINOCUT In this process, the artist uses tools to cut away areas from the surface of a linoleum sheet (often backed with wood) in order to leave raised surfaces. These uncut portions receive the ink in relief and are printed to create an image. A reduction linocut is a print process that prints colors in succession. The different colors are achieved by printing one color on all the paper supports, then cutting away more from the same plate, then printing another color over it. The first color appears only in the areas that were not cut away later. This is repeated until all colors are printed.

LITHOGRAPH A lithograph is made by drawing with a greasy pencil or crayon on stone. After the drawing is executed on the lithography stone, the stone is coated with a thin layer of gum arabic. The image area is washed out with a solvent. Asphaltum is rubbed into the exposed areas, fixing the image. The stone is then rolled with oil-based printer's ink. Next it is washed with water; the gum arabic washes out and opens the stone to water. The stone is again rolled up with ink and then run through the press with paper. The process may be used to create multiple prints or impressions of the image, called an "edition." An aluminum plate may also be used in place of the lithography stone. The word "lithograph" literally means "drawing on stone."

MATRIX The surface or form (e.g, lithographic stone, linoleum block, metal plate) used to make a print.

MONOPRINT A unique print made by printing using an etched or engraved or other fixed matrix. Variations in a series of monoprints are often made by a change in color, whether in the background or in the key plates. No two prints in the series are the same.

MONOTYPE A process in which the artist either brushes or draws on a featureless matrix, which is then used to print on paper, in ways that are difficult to repeat. Monotypes are singular images, "one of a kind."

POCHOIR "Stencil," in French. A process in which each image is deconstructed into a series of hand-cut stencils, one for each color, that are then used to reproduce the plates manually.

RELIEF PRINTING A process that involves rolling ink on the surface of a plate to make a print (examples include linocuts, woodcuts, monotypes, or monoprints). Ink is applied to the raised surface, and then the image is transferred to paper with a press. The cut-away areas do not receive ink and thus appear white, in contrast to the inked image.

RELIEF STENCIL A process that employs stencils printed in relief.

SERIGRAPHY Also known as silkscreen, serigraphy uses a frame with stretched silk as the matrix. The screen is treated, often with photo emulsion, rendering it a stencil form after light exposure. The ink is pressed through the fine weave and lays flat on the receiving surface.

SILOGRAPHY A form of lithography, also referred to as "waterless lithography" or "driography." Silography uses silicone instead of the water used in regular lithography to repel the greasy ink. The resulting prints are called "silagraphs."

UNIQUE LINOCUT A monoprint that is a linocut.

WOODCUT A relief print made by a process that involves carving away portions of the surface of a wood block, inking the uncarved surfaces, and then printing the image.

ARTISTS IN RESIDENCE AND YEAR(S) IN RESIDENCY, CROW'S SHADOW INSTITUTE OF THE ARTS 2001–2016

Frank Janzen, master printer for all residencies, except as noted

*Indicates Golden Spot Residency funded by the Ford Family Foundation

Rick Bartow

Gabrielle Belz

Pat Boas

Joe Cantrell

Adnan Charara

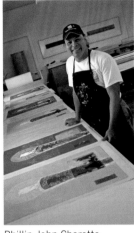

Phillip John Charette

Daniel Duford

Jim Denomie

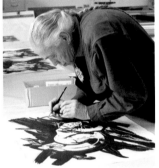

Vanessa Enos

Corwin Clairmont

RICK BARTOW
(Wiyot, 1946–2016)
2001 (Eileen Foti, Printer), 2004, 2008, 2013

GABRIELLE BELZ
(Māori, Ngā Puhi, Te Ātiawa, b. 1947)
2011

PAT BOAS
(U.S., b. 1952)
2012*

JOE CANTRELL
(Cherokee, b. 1945)
2016

ADNAN CHARARA
(U.S., b. Sierra Leone, 1962)
2009

PHILLIP JOHN CHARETTE
(Yup'ik, b. 1962)
2005, 2008, 2009

CORWIN CLAIRMONT
(Salish Kootenai, b. 1946)
2012

JIM DENOMIE
(Ojibwe, b. 1955)
2011

DANIEL DUFORD
(U.S., b. 1968)
2015*

VANESSA ENOS
(Walla Walla/Yakama/Pima, enrolled Northern Cheyenne, b. 1981)
2009

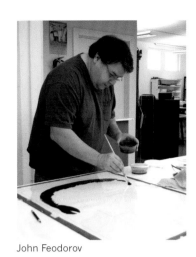

John Feodorov

Woun-Gean Ho

Arnold Kemp

Jeffrey Gibson

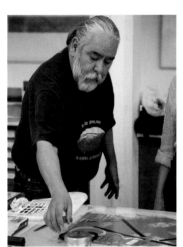

Joe Feddersen

Don Gray

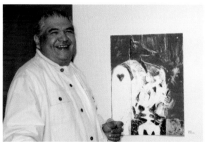

Ric Gendron

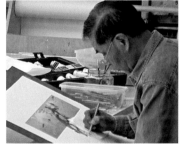

George Flett

Edgar Heap of Birds

Damien Gilley

JOE FEDDERSEN
(Colville Confederated Tribes, b. 1953)
2003

JOHN FEODOROV
(Navajo, b. 1960)
2011

GEORGE FLETT
(Spokane, 1947–2013)
2007

RIC GENDRON
(Colville Confederated Tribes, b. 1954)
2010

JEFFREY GIBSON
(Mississippi Band of Choctaw/Cherokee, b. 1972)
2008

DAMIEN GILLEY
(U.S., b. 1977)
2013*

DON GRAY
(U.S., b. 1948)
2009

EDGAR HEAP OF BIRDS
(Cheyenne, b. 1954)
2001

WUON-GEAN HO
(U.K., b. 1973)
2005, 2010

ARNOLD KEMP
(U.S., b. 1968)
2012*

Eva Lake

Ramon Murillo

Truman Lowe

James Luna

Larry McNeil

Frank LaPena

James Lavadour

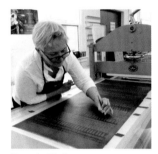

Victor Maldonado

Brenda Mallory

Whitney Minthorn

EVA LAKE
(U.S., b. 1956)
2011*

FRANK LAPENA
(Wintu, b. 1937)
2012

JAMES LAVADOUR
(Walla Walla, b. 1951)
2002, 2004, 2006, 2010, 2011, 2015

TRUMAN LOWE
(Ho-Chunk, b. 1944)
2002

JAMES LUNA
(Luiseño, b. 1950)
2011

VICTOR MALDONADO
(U.S., b. Mexico [Purepecha]), 1976)
2014*

BRENDA MALLORY
(Cherokee, b. 1955)
2016*

LARRY MCNEIL
(Tlingit/Nisga'a, b. 1955)
2004, 2007

WHITNEY MINTHORN
(Umatilla, b. 1990)
2013

RAMON MURILLO
(Shoshone-Bannock, b. 1956)
2005

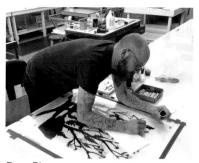
Ryan Pierce

Blair Saxon-Hill

Susan Murrell

Susan Sheoships

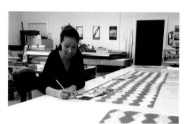
Wendy Red Star

Michelle Ross

Jenene Nagy

Sara Siestreem

Lillian Pitt

Ryan Lee Smith

SUSAN MURRELL
(U.S., b. 1973)
2012*

JENENE NAGY
(U.S., b. 1975)
2011*

RYAN PIERCE
(U.S., b. 1979)
2016*

LILLIAN PITT
(Wasco/Yakama/Warm Springs, b. 1943)
2006, 2013

WENDY RED STAR
(Apsáalooke, b. 1981)
2010, 2015*

MICHELLE ROSS
(U.S., b. 1962)
2015*

BLAIR SAXON-HILL
(U.S., b. 1979)
2013*

SUSAN SHEOSHIPS
(Cayuse/Walla Walla, b. 1951)
2008

SARA SIESTREEM
(Hanis Coos, b. 1976)
2013*

RYAN LEE SMITH
(Cherokee/Choctaw, b. 1972)
2004

Shirod Younker

Jeremy Red Star Wolf

Marie Watt

Kay WalkingStick

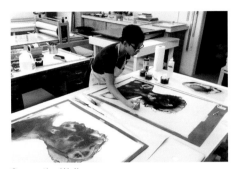
Samantha Wall

Melanie Yazzie

Adam Sorensen

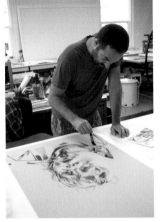
Storm Tharp

Zhang Yunling

Marty Vreede

ADAM SORENSEN
(U.S., b. 1976)
2014*

STORM THARP
(U.S., b. 1970)
2011*

MARTY VREEDE
(New Zealand, b. 1955)
2009

KAY WALKINGSTICK
(Cherokee, b. 1935)
2003

SAMANTHA WALL
(U.S., b. South Korea, 1977)
2016*

MARIE WATT
(Seneca, b. 1967)
2002, 2003, 2005, 2011

JEREMY RED STAR WOLF
(Umatilla/Cayuse/Walla Walla, b. 1977)
2006, 2008

MELANIE YAZZIE
(Navajo, b. 1966)
2012

SHIROD YOUNKER
(Coquille/Miluk Coos, b. 1972)
2014*

ZHANG YUNLING
(Naxi [Chinese], b. 1955)
2003

EXHIBITION HISTORY, CROW'S SHADOW INSTITUTE OF THE ARTS 2005–2018

2005
Clatsop Community College, Astoria, Oregon

2006
Hallie Ford Museum of Art, Willamette University, Salem, Oregon

2007
Wenatchee Valley Museum and Cultural Center, Wenatchee, Washington

2008
Pataka Museum of Arts and Culture, Porirua City, New Zealand

Schneider Museum of Art, Southern Oregon University, Ashland, Oregon

Hallie Ford Museum of Art, Willamette University, Salem, Oregon

2009
Coos Art Museum, Coos Bay, Oregon

Peggy Lewis Gallery at Allied Arts, Yakima, Washington

Willow Gallery, Walla Walla, Washington

Columbia Center for the Arts, Hood River, Oregon

2010
Fort Walla Walla Museum, Walla Walla, Washington

Winestock LLC, Oregon City, Oregon

Hallie Ford Museum of Art, Willamette University, Salem, Oregon

2011
C. N. Gorman Museum, University of California, Davis, California

Legends Santa Fe, Santa Fe, New Mexico

Goudi'ni Native American Arts Gallery, Humboldt State University, Arcata, California

Portland Airport, Port of Portland, Portland, Oregon (2011–12)

Hallie Ford Museum of Art, Willamette University, Salem, Oregon (2011–12)

2012
Atelier 6000, Bend, Oregon

Portland Art Museum, Portland, Oregon

Tamástslikt Cultural Institute, Pendleton, Oregon

2013

Pendleton Center for the Arts, Pendleton, Oregon

Crossroads Carnegie Art Center, Baker City, Oregon

The Arts Center, Corvallis, Oregon

Pendleton Art and Frame, Pendleton, Oregon

Art Gallery at Lower Columbia College, Longview, Washington

PJ Chessman Gallery, Lincoln City Cultural Center, Lincoln City, Oregon

Josephy Center for Arts and Culture, Joseph, Oregon

Hallie Ford Museum of Art, Willamette University, Salem, Oregon (2013–14)

IAIA Museum of Contemporary Native Arts, Santa Fe, New Mexico (2013–14)

2014

National Museum of the American Indian, George Gustav Heye Center, New York City

National Museum of the American Indian, Washington, DC

Columbia City Gallery, Seattle, Washington

Rogue Gallery and Art Center, Medford, Oregon

Tacoma Art Museum, Tacoma, Washington

Linfield College, McMinnville, Oregon

Stevens Gallery, Whitman College, Walla Walla, Washington

Helzer Gallery, Portland Community College, Rock Creek Campus, Portland, Oregon

Missoula Art Museum, Missoula, Montana

Eitlejorg Museum of American Indian and Western Art, Indianapolis, Indiana (2014–15)

2015

Jacobs Gallery, Eugene, Oregon

Schrager and Clarke Gallery, Eugene, Oregon

Fred Jones Jr. Museum of Art, University of Oklahoma, Norman, Oklahoma

Ascent Seattle, Seattle, Washington

2016

Broadway Gallery, Portland State University, Portland, Oregon

Josephy Center for Arts and Culture, Joseph, Oregon

Heritage University, Toppenish, Washington

Missoula Art Museum, Missoula, Montana

2017

Oregon College of Art and Craft, Portland, Oregon

Newport Visual Arts Center, Newport, Oregon

Hallie Ford Museum of Art, Willamette University, Salem, Oregon

2018

Whatcom Museum, Bellingham, Washington

Jordan Schnitzer Museum of Art, Washington State University, Pullman, Washington

BOARD OF DIRECTORS, CROW'S SHADOW INSTITUTE OF THE ARTS 1992–2017

Vivian Adams

Lorie Baxter

Cecile Bentley

Julie Burke

Donna Caldwell

Steve Charles

Annie Charnley Eveland (Current)

Shari Dallas

Tom Diamond

Kay Fenimore-Smith (Current)

Charles Froelick (Current)

Jeanine Gordon

Jerry Greenfield

Bill Griffith

Marie Hall (Current)

Tom Hampson

Keiko Hara

Raphael Hoffman

Cathy Hojem

Jean Hutton

Bill Johnson

Brad Jones

Dennis Katayama

Bonnie Laing-Malcolmson (Current)

James Lavadour (Current)

Alison Mowday Gold (Current)

JoAnn Lavadour

Elizabeth Leach

Michelle Liberty

Henry Lorenzen

Jim Love

Barbara Mason

Eric McCready

Antone Minthorn (Current)

Jo Motanic Lewis

Maria Nelson

Mary Ann Normandin

Prudence F. Roberts (Current)

Tom Rudd

Donald Sampson

Lori Sams

Mari Sams Tester (Current)

Jim Sawyer

Andrea Smith

Rennard Strickland

Shelby Tallman (Current)

Dave Tovey

Patrice Hall Walters (Current)

Lucinda Welch

Elizabeth Woody

Driek Zirinsky

HALLIE FORD MUSEUM OF ART STAFF

John Olbrantz
The Maribeth Collins Director

Carolyn Harcourt
Assistant to the Director

Jonathan Bucci
Collection Curator

Elizabeth Garrison
The Cameron Paulin Curator of Education

Andrea Foust
Membership/Public Relations Manager

Silas Cook
Contract Preparator

Emily Simons
Gallery Receptionist

Leslie Whitaker
Gallery Receptionist

Frank Simons
Safety Officer

Cruz Diaz de Estrada
Custodian

CROW'S SHADOW INSTITUTE OF THE ARTS STAFF

Karl Davis
Executive Director

Frank Janzen
Master Printer

Nika Blasser
Marketing Director

heather ahtone is currently the James T. Bialac Associate Curator of Native American and Non-Western Art at the Fred Jones Jr. Museum of Art at the University of Oklahoma in Norman. heather is interested in the intersection between tribal knowledge and contemporary art. Working in Native arts communities since 1993, she has curated numerous exhibitions, published articles on her research and exhibitions, and continues to seek opportunities to broaden discourse on global contemporary Indigenous arts. In addition, she is committed to serving the arts community of Oklahoma. She is a member of the Chickasaw Nation and has strong family ties to the Choctaw and Kiowa communities.

REBECCA J. DOBKINS is Professor of Anthropology and Curator of Native American Art at the Hallie Ford Museum of Art at Willamette University in Salem, Oregon. Her areas of interest include traditional and contemporary Indigenous arts, tribal museums and museum display, and the intersections between Indigenous arts, sovereignty, and environmental resources. She has written about and organized exhibitions of work by Rick Bartow, Joe Feddersen, James Lavadour, Marie Watt, and many other Native artists, and has frequently collaborated with Crow's Shadow Institute of the Arts over the last two decades.

PRUDENCE F. ROBERTS is an art historian who teaches at Portland Community College and is director of its Helzer Gallery. A former curator of American art at the Portland Art Museum, Prudence's research and writing focus on the art and history of the Pacific Northwest. She is the author of several essays on contemporary Northwest artists, and has also written about the early days of the Portland Art Museum. She served as curator of *Portland2012*, a biennial organized by the Disjecta Contemporary Art Center, where she is currently a board member. Roberts is also a founding board member of Crow's Shadow.

This book was published in connection with an exhibition arranged by the Hallie Ford Museum of Art at Willamette University entitled *Crow's Shadow Institute of the Arts at 25*. The dates for the exhibition were September 16 – December 22, 2017.

Financial support for the exhibition and book was provided by a major grant from the Ford Family Foundation. Additional financial support was provided by a grant from the James F. and Marion L. Miller Foundation; with funds from an endowment gift from the Confederated Tribes of Grand Ronde, through their Spirit Mountain Community Fund; and by general operating support grants from the City of Salem's Transient Occupancy Tax funds and the Oregon Arts Commission.

Designed by Phil Kovacevich

Photography by Dale Peterson, except pp. 150–154 and as otherwise noted.

Editorial review by Sigrid Asmus

Printed and bound in Canada by Friesen's Book Division

Front cover: JAMES LAVADOUR *Land of Origin*, 2015, ed. 18, suite of four, three-color lithographs on Arches 88 white paper, 22 ½ x 30 ¼ in. each, 45 x 60 ½ in. overall, CSP 15-101 a, b, c, d.

Back cover photo by Walters Photographers.

Frontispiece photo by Nika Blasser.

Library of Congress Control Number 2017937848
ISBN 9781930957787

Distributed by
University of Washington Press
P.O. Box 50096
Seattle, WA 98145-5096